LIGHT & SHADOW

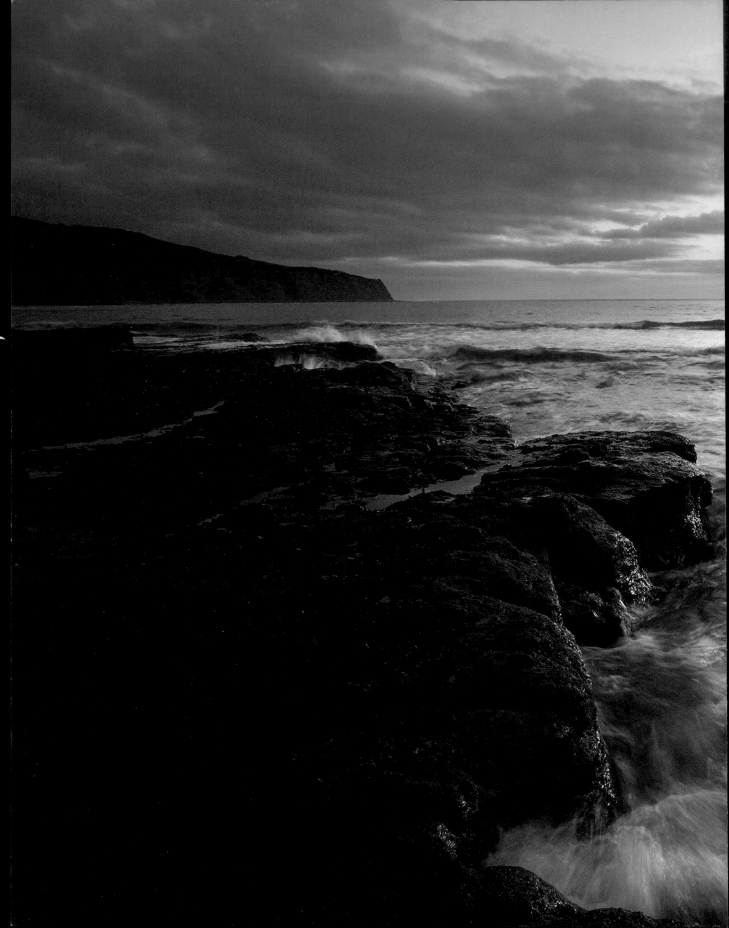

CONTENTS

Preface 6
Introduction 8

LIGHT
Light 12
Light Source 14
Direct Light 15
Diffuse Light 23
Reflection, Scattering and Absorption 33
Magic Hours 39
Colour 50
Light and Shadow Depth 56
Black and White 61

FORM
Form 68
Structure 70
Lines and Intersections 71
Geometric Shapes 75
Symmetry and Asymmetry 79
Contours 83
Texture 88
Composition 92
Elements 93
Positive and Negative Space 97
Relative Height 101
Distance and Scale 105
Thirds and the Golden Ratio 114

TIME
Time 122
The Passage of Time 124
Changing Seasons 128
Waiting: Working with Stormy Weather and Unpredictable Light 134
Deep Time 139

Conclusion 142
Further Reading 143
Technical Details 144

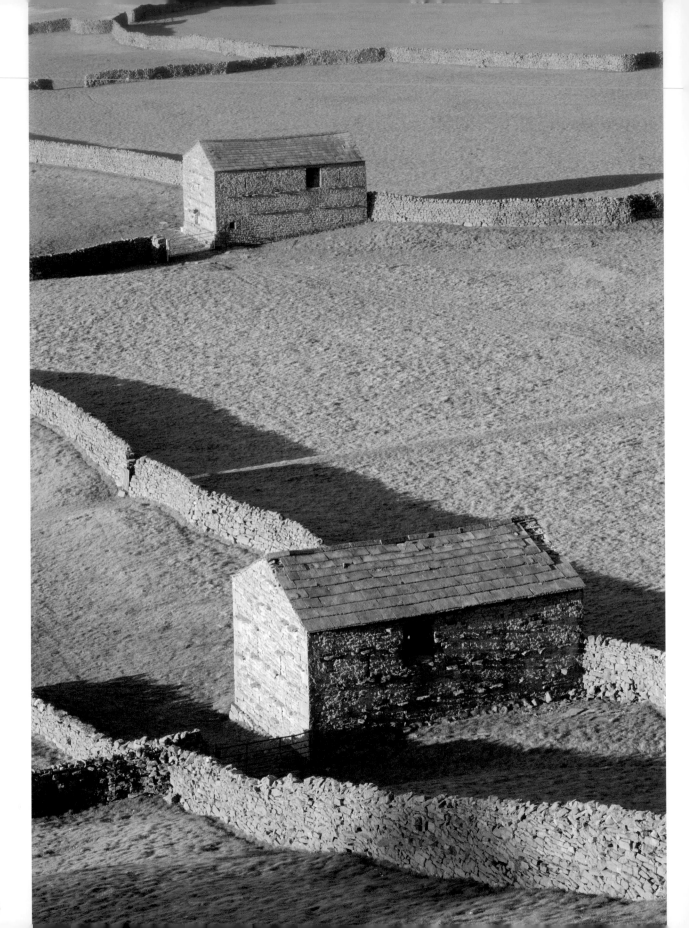

PREFACE

About half a lifetime ago I thought I was going to become a painter. I worked long and hard at it, but I could never paint what was inside my head. Something was certainly lost in translation, and it was a source of continual frustration. Meanwhile, I got seriously interested in SLR cameras in my early teens. Then at college I discovered darkrooms for the first time, and this was the catalyst for an enduring obsession.

I went on to university to study fine art. Still trying to paint but failing miserably, I started to make more photographs. Then, without a conscious choice having been made, I noticed that the photography had taken on a life of its own – the proverbial lightbulb flashed. What I realised was that if a scene was already there in front of me, by applying camera technique and a bit of imagination, I could document the world and put my stamp on it. I have not picked up a paintbrush since.

The technical concepts once applied to painting now inform the way I make photographs. Combined with my study of art history and the science of visual perception, theory and practice have come together in a way that heightens my appreciation of the natural world. This multi-faceted approach has proved invaluable and is the inspiration for this book.

INTRODUCTION

When I first picked up a camera, I had the notion that I was photographing 'things', and in some respects that was correct. However, in the purest sense, light is the substance captured in camera. Photography is a study of opposites: analysing light falling on to surfaces and the subsequent creation of shadows. Of equal importance are all the shades of grey that lie in between. Without illumination our world is shadow and mystery, in both reality and metaphor.

The theme of contrast works its way through all aspects of this book. While it is an oversimplification to say that we see the world solely in terms of polarised extremes, they do play strong roles in cognitive understanding. Light and dark, large and small, rough and smooth, warm and cold, positive and negative – thinking about contrasts when approaching our environment is instructive. Many of the ideas I explore photographically are built around opposing elements, composed to bring them into balance with each other.

Sunlight maintains most terrestrial and many aquatic organisms, from tiny plankton to massive trees. Humans have a complex physiological and psychological relationship with light. Too much or too little exposure to it and our natural body rhythms are disrupted, which will eventually have a marked effect on wellbeing. We are naturally attuned to variations in the 'quality of light'.

Linked with sensitivity to light is our response to colour, perception of which comes from optical processing of the different light wavelengths as they react with various surface textures in our environment. Awareness of colour and tonal variation gives meaning to the world around us, and is integral to understanding and adapting to our surroundings. However, this does not explain why certain colours should have elusive associations that have become embedded in our descriptive language. We live in a rich culture of visual creativity that uses colour to express feelings, laden with collective symbolism but also private meaning.

The photographer's craft is the manipulation of tone and colour to document what they see. This can only be done after developing awareness of the 'quality of light' that is the foundation of good image making. When facing the challenge of getting the best from natural light, photographers rely on previously established principles and shared concepts to create coherent images with broad appeal. Some of this attraction is experienced at an unconscious level. Without being able to explain why it should be so, some things just look more 'right' than others. This is the realm of the 'gut instinct', something that I believe in following.

Light reveals form. Interpreting form in the world at large is the material from which an image is composed. All things can be broken down into separate components, which is precisely what our brains are organised to do in order to make sense of our environment. We take this information processing for granted as it happens automatically. For the photographer to see the world clearly enough to be able to represent it to someone else means consciously making time to analyse the scene. This requires intense observation, a skill that leads to a communicable understanding of the subject. Making it an artwork is the last stage of that process, raising the question of how to use space within the viewfinder. Deciding what goes in, what gets left out and the relationship between visible elements.

When a photograph is so deliberately arranged, what kind of reality can it be held to represent? Well, the camera always lies to a certain extent. The photographer is not taking a true record of a place but a selected view carefully composed to convey an idea. When documenting natural landscapes, there is usually an attempt at realism, but that is filtered through the mind and preoccupations of the photographer. Add to this the enhanced manipulation techniques provided by digital photography and the issue becomes decidedly cloudy.

Rather than get too mired in this debate, it is safer to dodge the question of what reality is offered by photography and conclude whether or not an image works. A large part of that assessment is subjective and very much in the beholder's eye. That said, there are some fundamental principles that underline appealing images. A well-composed photograph should invite the viewer to explore it, and to allow a connection to that captured moment. A thoughtfully photographed landscape has the power to transport the viewer to that place and reveal something of that environment's essence.

In this exploration of the techniques underlining my practice, I will analyse the different threads that combine to make interesting photographs. I will start with a comprehensive discussion of light, followed by form and move on to the all-important aspect: time. I have come to think of these factors as a trio, each aspect referring to and influencing the other. Photographs result from a temporary balance between these components, working with natural conditions to create harmony. Once these concepts have been learnt, they become implicit and will transform how you see the world.

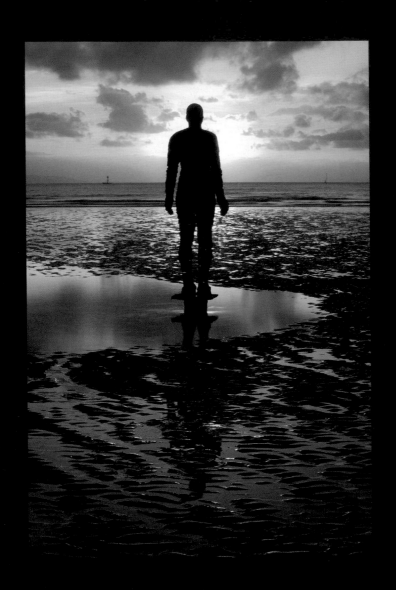

LIGHT

LIGHT

Light is visible electromagnetic radiation. Only a small proportion of electromagnetic wavelengths, in the range of around 400–700 nanometres, are discernable to the human eye. Starting with the shortest wavelength first, the visible spectrum is formed from violet, blue, green, yellow, orange and red. Outside this range are ultraviolet and infrared, whose wavelengths are, respectively, too short and too long to fall within the perceptible range. Because the colour spectrum is continuous, no clear boundary exists between these colours, being merely convenient approximations. When all wavelengths are present in equal intensity, they combine to make 'white light', which is a close correlation to sunlight at noon in a cloudless sky.

Wavelengths are present is differing quantities dependent on the level of visible sunlight, which affects not only light's intensity but also its colour. We know this implicitly as humans are primed to be sensitive, being only too aware of the differences between overcast and bright conditions. If we measure the disparity using the standard light measurement unit, lux (lumens per square metre), a grey day is somewhere in the region of 10,000–25,000 lux, whereas a cloudless midsummer noon is around 100,000 lux – up to ten times brighter.

Therefore, it is not surprising that this difference is recognised and commented upon. How often do you look out, see grey skies and feel despondent? Compare this to the positive associations we have with bright sunshine and its vital warmth and vivacity. There is a connection between the study of natural light and the emotional world of the photograph. Light, or its absence, can be used to inspire a range of responses.

The problem with making photographs in natural light is that it does as it pleases, the right weather being key to any kind of success. It is the landscape photographer's job to make the best of whatever is available, so that the location can be recorded faithfully. However, the obsession with the quality of light remains. I prefer to work at the day's edges, those golden hours just after dawn and before sunset when colours are radiant and the shadows are soft and long. I am equally happy working with the unpredictable illumination associated with storms, although I may have to wait all day for the perfect light.

In order to get the best from my equipment, it is important to 'read' lighting conditions and take an educated guess as to how this will translate into a photograph. This takes experience but it all starts with gauging the light source. As cameras are not as sophisticated as our eyes, they struggle to record detail when presented with a large contrast range. They will prioritise one over the other, meaning that either shadow or highlight detail is in danger of being lost. There are ways around this problem, using graduated filters over the lens or combining different exposures together at the processing stage, but by far the best method is to work with the lighting, rather than against it, in order to keep the problem to a minimum.

Understanding how light behaves in relation to the camera underpins the creation of good images. It is a broad subject and one that entails so much complexity and natural variation that using it to advantage is the work of a lifetime. A photograph can succeed or fail on use of lighting alone. An appealing subject taken in nondescript lighting is less pleasing than a mundane subject captured in excellent lighting. It is the range of illumination that paints the atmosphere of an image.

Light Source

The light source for landscape photographs will, with some notable exceptions, be the sun. Its impact on the environment will alter depending on how much sunlight is visible and the direction from which it is coming. While our brains are sophisticated enough to recognise and balance changes in colour temperature, a camera does not 'see' colour and cannot compensate for the absence of certain wavelengths without help. This is why either using filters (on film) or choosing the correct white balance (on digital) is necessary to avoid what is termed a 'colour cast': an unnatural bias towards a particular colour.

Light's colour is measured on the Kelvin scale. We use helpful, but not absolute, averages to determine the colour of light. Bright sunlight has a temperature of 5000–6000°K; a cloudy day is around 7000°K. As the sun's rays become less apparent the colour temperature becomes bluer or 'cooler'. If a photograph is taken in the shade on a sunny day, the temperature is around 8000–9000°K and is blue. Rather confusingly it has become the basic staple of our colour concepts to state that red is warm and blue is cool. However this is contrary to the Kelvin scale, in which the opposite is true, and can be demonstrated by heating a metallic object. As the temperature rises, the metal glows and the colours change from yellow-orange through to blue. Suffice to say, I go with the conventions of descriptive language and red is warm and blue is cool in my world.

It is important to remember that initially the camera is concerned only with tone to create the correct exposure. The temperature of light does not affect the balance of light and dark, but it will alter colour in the final photograph. To visualise what the camera sees, it is helpful to think of the world in terms of monochrome. Admittedly this is a huge imaginative leap but it makes sense when considering the way light information is processed when it reaches the eye as colour and tone are dealt with separately. The retina has light sensitive rods to process tonal contrast, whereas it is the job of receptive cone cells to process colour. However, because this mechanism appears to happen simultaneously it takes conscious effort to split the information.

Before setting up a photograph there is a list of helpful questions that can be referenced to determine lighting characteristics. Are there are any shadows, if so how apparent are they? Do they appear hard-edged or soft-edged? Do surfaces sparkle and glisten? Or are most tones a variation on a grey theme? Noting this will define how broad

a contrast range there is within the subject. A principal factor dictating sunlight's intensity and colour is how much cloud there is between the sun and the subject. Put simply, natural light can be divided into two categories: direct and diffuse.

Direct Light

When no cloud is present or significant gaps in the cloud layer let sunlight through, the sun is a small and intense light source creating strong, crisp-edged shadows and highlights that sparkle on reflective surfaces. A significant majority of lightwaves reach the ground. Direct light is conventionally thought of as the optimum sort of lighting for photographing larger vistas. The major concern with regard to direct lighting is the position of the sun in relation to the subject and to the camera. The light emitted by the sun is directional and this must be considered when trying to reveal the best aspect of the scene.

Side-lighting

When direct light strikes an object side-on relative to the position of the camera, it is referred to as side-lighting. This is when the camera lens is oriented away from the sun at around a 90-degree angle. Side-lighting illuminates one side only of an object, leaving the other side in shadow. In between the contrasting extremes it is possible to see gradations of tone – from light grey, through mid-tone to dark grey. The full range of tones forms the illusion of three-dimensional contours in a two-dimensional image. Artists often refer to side-lighting as 'modelling light' for this reason.

I generally prefer to use side-lighting because it works well across the majority of landscape subjects. Although this lighting direction can be used throughout the day, unless the sun is overhead, the ideal time to use it is when the sun is low on the horizon. At the beginning and end of the day, the angle of light causes longer, softer and more interesting shadows.

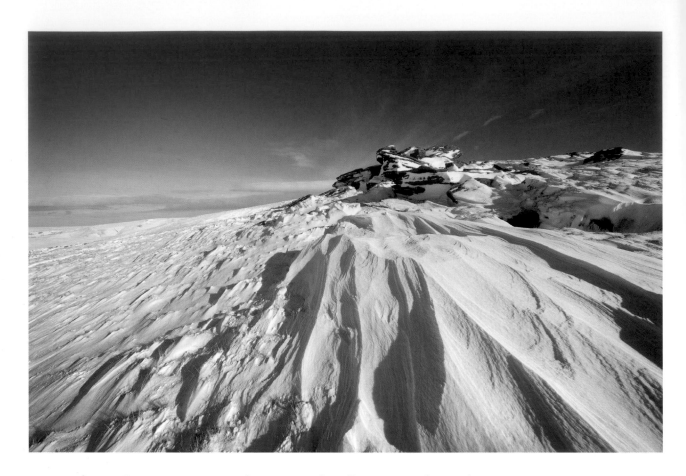

Kinder Scout, rocks in drift, Derbyshire
January

On a mostly flat mountain plateau primarily covered by snow, apart from the odd rocky tor emerging through the white blanket, searching for a good subject was surprisingly difficult. When I saw the ridges in the snow, cut by a fierce wind, I realised that they would have photographic potential. However, finding the right angle of lighting in relation to this subtle detail was crucial. The ridges' low undulations became particularly apparent when they were aligned with the sun falling on the scene from approximately 90 degrees to my right. The elevated areas are revealed in strong light, while the dips in between the ridges are cast into shadow. Even the exceptionally low-relief patterns, where the wind has just scoured the surface, are noticeable in clear sunlight that creates contrast between light and dark edges.

This image was taken in January, meaning that even at mid-morning the sun was not especially high in the sky. If it had climbed much higher, the effectiveness of the side-lighting would have been reduced as this low angle achieves the most noticeable cast shadows. As the sun approaches noon, the shadows become increasingly short and more harshly defined before lengthening once again towards the end of the day.

Salt Cellar, Derwent Edge, Derbyshire/South Yorkshire border
August

Derwent Edge runs roughly north to south, causing it to be side-lit in both morning and afternoon, thus giving a choice between two good options. However, it is a location that I have visited often and with familiarity have come to prefer the Salt Cellar tor in afternoon light. The key benefit of side-lighting is that it clearly defines the tor's sculptural form. Golden illumination is splashed over one side, while the other aspect is shaded, describing the textures and contours of eroded sandstone. This effect is also seen to a lesser extent across the rest of the scene, allowing the rock formation to stand out as the most three-dimensional object.

The added advantage of shooting in the early evening light is that the sunlight is strong enough to produce dramatic highlights but is not so overwhelming that the shadow areas are pure black. It is important to retain some level of detail in shadows so that they are primarily dark grey rather than black, otherwise they can overwhelm the photograph, acting like holes sucking in the rest of the light.

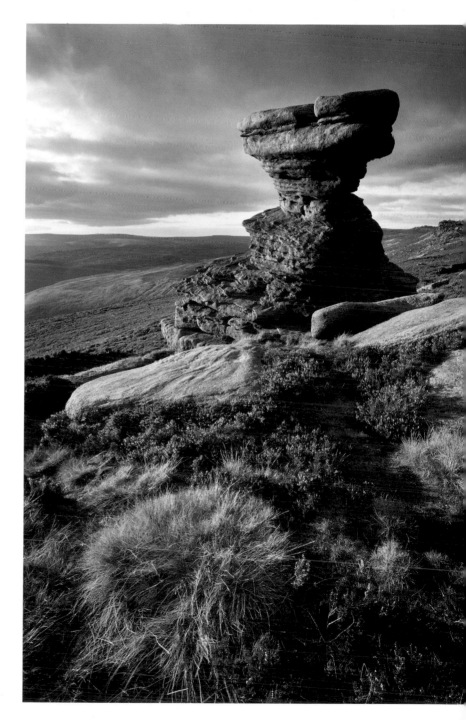

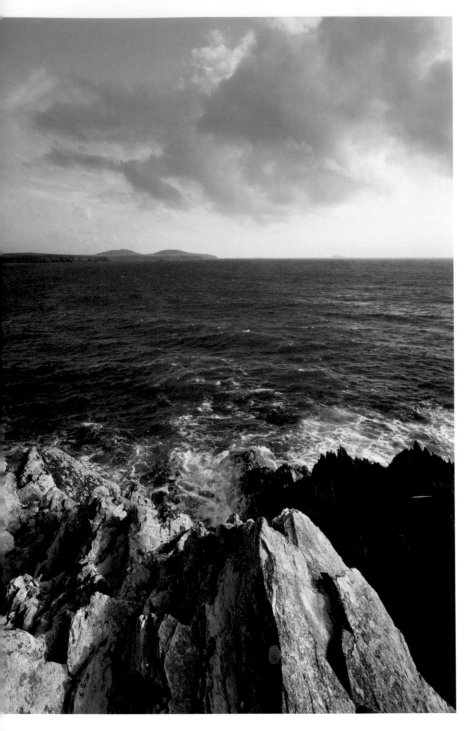

Soft afternoon sunshine bathes jagged rocks jutting into the Irish Sea. Once again side-lighting offers the best range of illumination for this vista. The rocks are interesting for their chaotic arrangement; layer upon layer of sedimentary rock has been tilted by geological upheaval. The light's direction reveals the strata's fine detail. Every undulation is picked out against the corresponding shadow, edges appearing all the sharper because of tonal contrast. Cropping the right-hand edge, so that the area appears dark, allows greater distinction and clarity for the closer, brighter rocks.

The effect of side-lighting on both sea and sky are not to be overlooked. The wave detail is picked out by subtle tonal gradation, resulting in an area that appears dynamic rather than flat. Clouds are an important part of any composition where a fair amount of sky is included. Here fluffy white cumulus appears illuminated on one side and in soft shadow on the other, making them interesting objects.

Trwynhwrddyn, looking out to sea, Pembrokeshire
June

Back lighting

Placing a subject between the sun and the camera position can create dramatic visual effects. However, it is a much harder type of lighting to work with, as (by its very nature) it leads to exaggerated contrast. Whatever object is back-lit will appear darker, perhaps putting it into total silhouette. Back-lighting works best with a clear and recognisable subject, one that looks good in simplified form. This particularly applies to creating silhouettes; a tree or a person forms a pleasing subject for back-lighting because they have a distinctive outline. Objects that are too bulky or shapeless do not work so well as they become ambiguous.

If back-lighting is transmitted through a translucent surface such as foliage or partial cloud, rather than creating an absolute black silhouette, a reduced amount of light will filter through the subject, creating dynamic effects. Another technique is to angle the camera downwards to exclude the sun, using the appropriate lens hood to ensure that no stray light affects the final photograph.

Take due caution when shooting straight into the glare of the sun. Not only is it bad for your eyes when looking through the viewfinder but it also has the potential to damage a digital camera's sensor. It is just about possible to include the sun directly in a photograph providing it is not too bright. This can be achieved around the hours of sunrise or sunset.

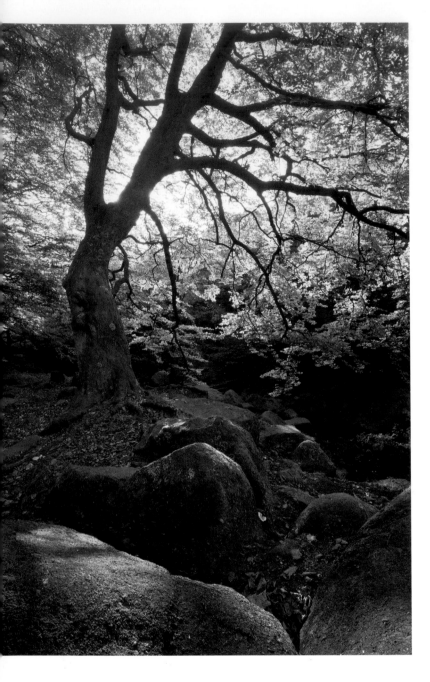

Back-lit trees are a good subject to work with. Semi-translucent leaves appear to glow, especially by comparison with the dark woodland environment. Where light does penetrate the canopy it is infused with the colour of the leaves, in this instance the pleasant yellow-green of turning autumnal foliage. Side-lit foliage appears less vibrant as the light is not seen to pass through the leaves: instead surface reflection causes a silvery sheen.

Once I decided that back-lighting would be appropriate for this subject, it was important to position the camera so that the sun appears behind the tree, ensuring that its full intensity is filtered by trunk and foliage. By avoiding the direct glare of the sun, the chance of making a successful photograph is greatly increased. Although this shot was taken late in the day, the sun was still strong enough to produce a fair amount of contrast, hence the intense highlights appearing between the leaves and the deep shadows spilling across the woodland floor. However, it is not bright enough to cause a total silhouette of the tree's trunk so there is still detail in the shadows. In stronger sunshine the silhouette effect is more marked.

Yarncliffe Wood, Longshaw Estate, Derbyshire
October

Callanish I, facing the dawn, Isle of Lewis
October

The standing stones of Callanish I had been on my list of sites to visit for a long while. In order to make best use of my time there, I decided to investigate the site the night before. With no sun visible, a compass was needed to check my bearings. Knowing where the sun would rise, I sought vantage points that would appear side-lit or back-lit the following dawn. Ultimately, this was good preparation as the opportunity for making images was brief, the rising sun soon disappearing behind a sheet of stratus cloud.

I wanted to reveal the stone circle's shape against the brooding sky and include the flash of light on the horizon. A low viewing angle positioned the stones as intended but back-lighting caused a problem. Although I could see detail in the shadows, the camera was not able record them faithfully owing to inherent limitations in its ability to capture tonal range. The solution was to take two separate exposures, one correct for highlights and another correct for shadows, and blend them together at the processing stage.

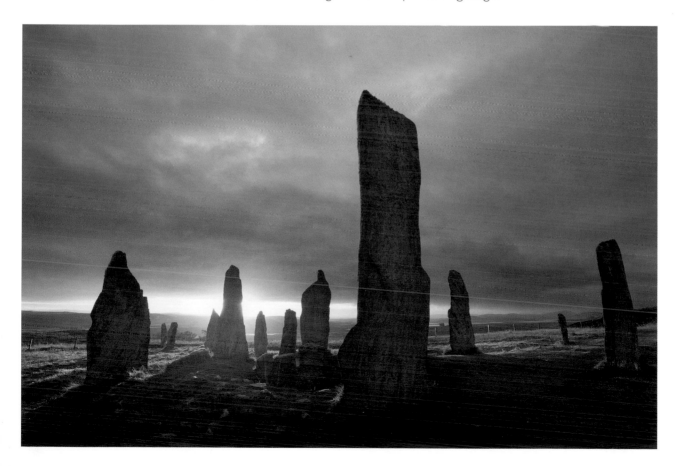

Outgoing tide at dawn, Boggle Hole, North Yorkshire
May

On a cold May morning, trying to keep warm while waiting for sunrise, I began to doubt whether the clouds would part enough to let direct light through. The camera was mounted on the tripod and the composition had been tweaked several times, so it was just a case of waiting patiently for the sun to make an appearance. Encouragingly, the telltale signs of a good sunrise were present, including a gathering pink band on the horizon and peachy hues splashed over cloud edges. A suitable gap in the cloud layer was all that was needed.

As I was determined to shoot into the sun, for maximum dramatic effect, the opportunity for taking the photograph would last just a matter of seconds. It was essential to catch the sun on the cusp of appearing from behind the cloud. Reacting too slowly would have allowed the light to become extremely bright, creating too much contrast. Here the sun is filtered through the thinnest cloud cover, making it appear slightly less intense. In spite of this, contrast problems were encountered. Consequently the final image is composed out of two photographs: one recording highlight detail, the other exposed for everything else.

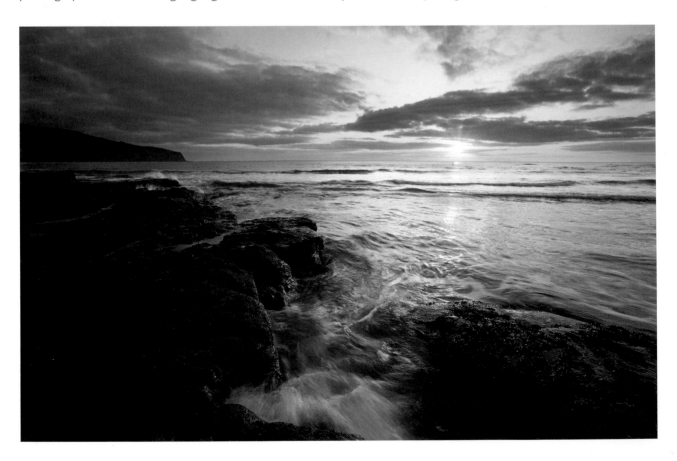

Flat lighting

When the sun is directly behind the camera, it is not ideal for landscape photography. The sun's position means that the scene is evenly lit, reducing shadows to a bare minimum. It also causes the added complication of having your shadow and that of the camera in the scene. Lighting from the rear is often thought of as 'flat' lighting, and I tend to avoid this situation as it rarely produces satisfactory results, though there will always be exceptions to the rule. If I discover an interesting viewpoint only to realise that the sun is behind me, I will note the scene and return when the subject is likely to be side-lit.

Diffuse Light

Cloudy

When the sun is totally or partially concealed by clouds it causes diffuse light. Sun obscured by cloud is thought of as a large light source lacking direction. The illumination we see is scattered skylight, which causes the characteristic bluish light on a dull day. While this is enough to provide even illumination, it is at a reduced intensity. The denser the cloud the lower the light levels. When it is overcast shadows are so soft and subtle that they are barely visible. As such it is often considered 'poor quality' light, although it does have its merits.

Hazy

When sunlight burns weakly through the cloud layer, it provides a small amount of shadow definition. In this sense the light is directional, but the sun is still at a very low intensity. This barest hint of shadows, with soft poorly defined edges, can be useful in some contexts.

Diffuse lighting is generally unsatisfactory for large landscapes because the sky is often very bright – a 'white out' – and the land will be comparatively dark; not only visually unimpressive but hard for the camera to capture the difference between the extremes. To get the best out of this type of lighting avoid including white sky in the frame, then the tonal range of the scene will be easier for the camera to record, generating a more balanced photograph. Diffuse light is better for photographing details or subtle ranges of colours. In strong light colours often appear washed out, whereas diffuse light reveals them in a more naturalistic way without the harsh shadows and highlights that can ruin a modest photograph.

Ob Breakish and Mullach na Carn, Isle of Skye
September

My initial impression of arriving on Skye was the grey veil stretching across the landscape. However, events improved on the approach to Ob Breakish, a bay near Broadford village. Subtle changes were occurring on the horizon as lighter patches of cloud began to appear and finally all the elements fell into place. To the west, the evocative peaks of Beinn na Callich rose to meet a textured cloudscape above a mirror-like stretch of water. In diffuse light the scene was almost monochrome, described by a palette of muted inky blues.

Still water is the perfect medium to photograph in low-light levels, reflecting even the barest range of illumination. This sidesteps the problem of dark land and bright sky so typical of overcast days. As the water is of a similar tone to the sky, it unites these two elements. If the light source were any stronger, the delicate silver of the water would be obliterated by garish highlights mirroring a far less subtle sky.

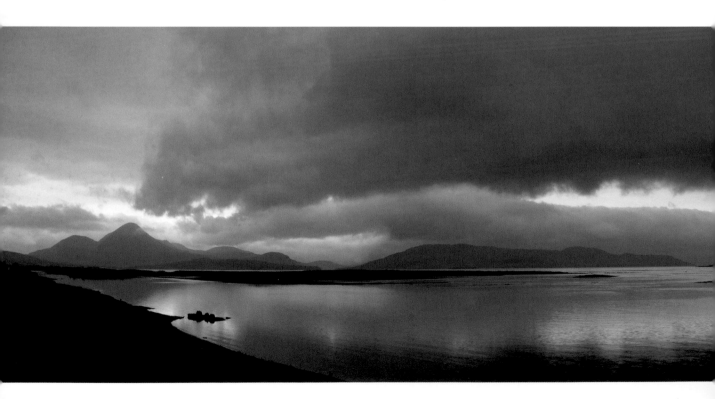

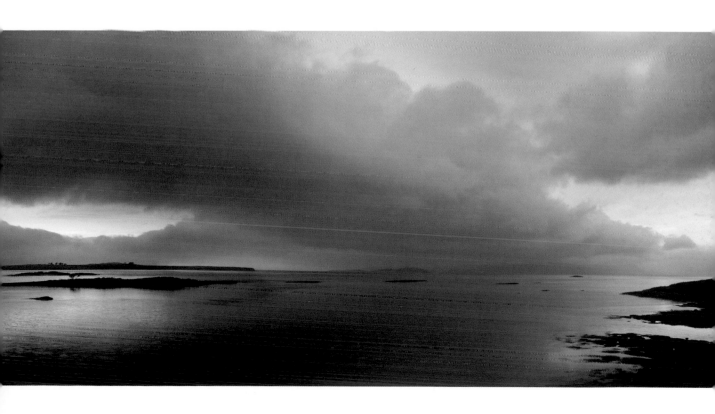

Willow buds, Lillingstone Lovell, Buckinghamshire
April

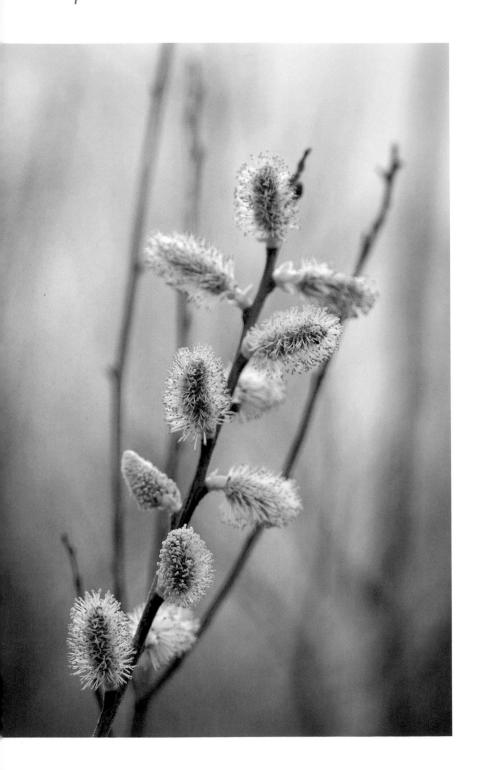

Waking early one morning, I found myself surrounded by unrelentingly gloomy mist. Passing by a wooded wetland, vibrant willow flowers glowed against the dull background. The willow's luminous yellow blooms appear before the leaves, and in early spring they are sometimes the strongest colour around.

Diffuse light is put to best use here; even tone does not distract from the blossom's natural intensity, and there are no are no shadows or intense highlights undermining this low-key plant portrait. The influence of the bright overcast sky is kept to a minimum by getting in close to the subject. Grey mist and the out-of-focus tangle of the wooded background combined to make a neutral space from which the yellow shines out. Admittedly it takes determination to find a suitable subject in diffuse light, but it is certainly not 'poor quality' light.

Elgol, rock textures, Isle of Skye
September

Hazy light greeted me on arriving at Elgol, which was a disappointment as I had envisaged golden afternoon light to do justice to this location. However, pessimism faded as a gentle hint of shadow definition developed, and the rock textures came to life.

Diffuse light proved perfect for the delicate spectrum of hues present in the granite pebbles and the peculiarly eroded sandstone cliff face. The strategic pebble at the front of the frame illustrates how important a shadow can be, even a soft one such as this. It adds vital depth, clarifying the pebble's presence through contrast with its smooth bright edges.

I took further versions of this shot as the sun burnt through the cloud layer, each one with the light successively less diffuse. Yet it was this one, bathed in the softest light, that was the most pleasing: the darker the shadows, the more distracting they became.

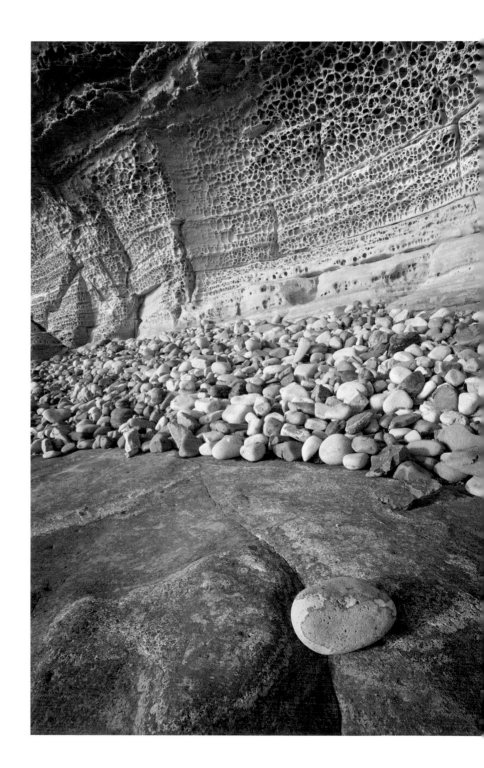

Twilight

A further example of diffuse light is seen around the hours of twilight when the landscape is neither dark nor bright and the scene is on the threshold of visibility. The sun, just below the horizon, scatters lightwaves in the upper atmosphere, which then disperse in the lower atmosphere, creating diffuse illumination. Twilight can be very atmospheric, particularly if the colour is reflected from strategically positioned clouds. It is well worth getting to a location in the hour before dawn, and also waiting until after dusk to see whether any interesting transitions occur.

Due to low-light levels, twilight is similar to working with cloudy and hazy light. Twilight has a certain dreaminess, rendering objects strangely. This effect is partly due to the limited range of colours caused by diffuse skylight; subjects take on a bluish cast, upsetting real hues.

Luskentyre, reflections at dusk, Isle of Harris
September

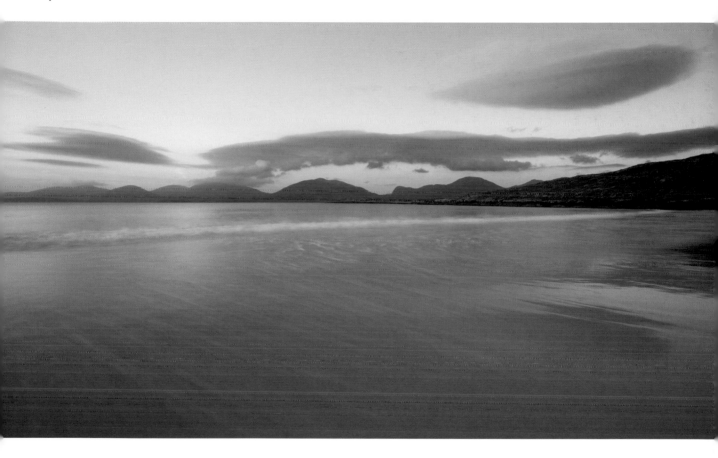

The sun had disappeared below the horizon about ten minutes before this photograph was taken. A pink glow still illuminated the clouds' edges, providing slight warmth in a predominantly cool-coloured scene. Once again using water has made this shot possible, for without reflected light on the landscape, the image would have appeared much flatter. The lighter tones visible in the water transform what would otherwise be an area of bland grey sand. A partial reflection of the lenticular cloud helps to bring definition into the vague foreground space, creating a connection between land and sky.

A shutter speed of two seconds captures the essence of the flowing tide. The softness recorded as the wave rushes towards the camera creates delicate traces of swell and movement, which are juxtaposed against the landscape's solidity. The disparity that exists between static objects and subtle blur seems an ideal theme to explore in pale twilight.

Big Moor, hawthorn tree and grasses, Derbyshire
November

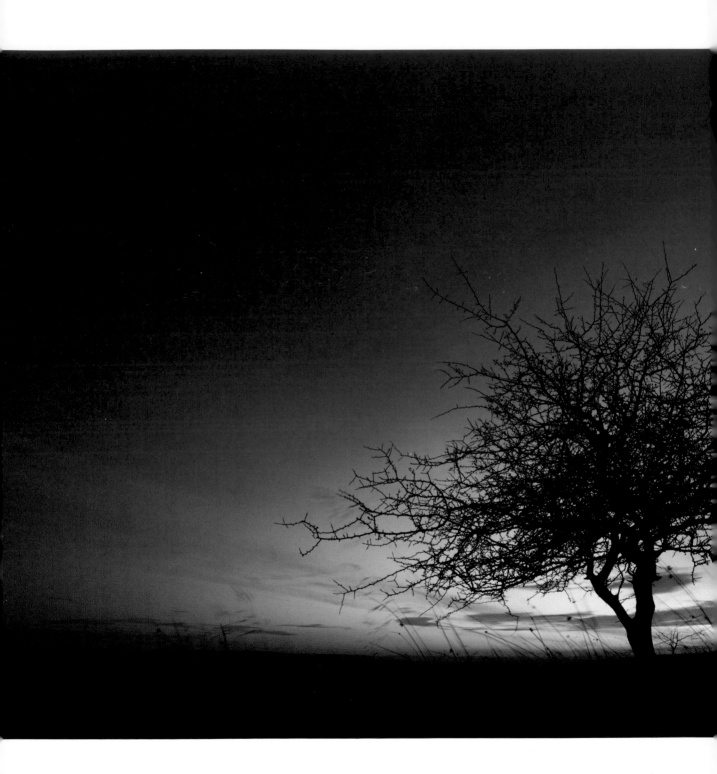

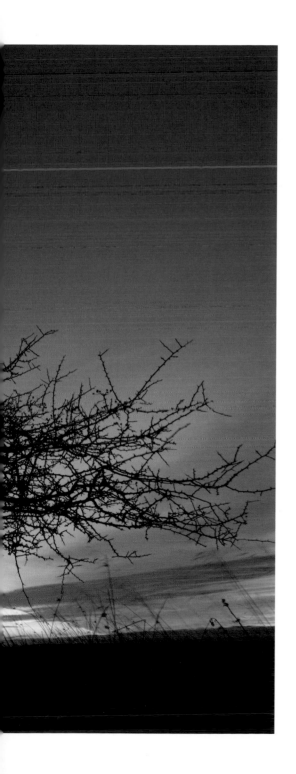

Driving home on a late autumn evening, the sunset had been a low-key affair more than half an hour earlier. But as the sky darkened, something interesting was happening on the horizon. A band of low cloud reflecting dipped sunlight was causing a persistent red afterglow, dispersing through magenta into the spectrum of blues in the sky. This luminous stripe formed a transition zone between the warm hues of dusk and the cool blue of fast approaching twilight.

In the middle of the Peak District, with no water for miles, the next best option was to find a subject that would make a strong silhouette against the colourful sky. Fortunately, it did not take long to find this squat but beautifully shaped hawthorn. I anticipated that the delicate structure of the dark branches would be picked out in sharp detail against the wash of colour behind. With minimal light levels it was necessary to use a two-second shutter speed to record the correct exposure. The camera captured the gentle movement of the grasses while the tree remained static by comparison.

This image features a minimal colour palette, bordering on monochrome. Only the barest hint of pink cloud, just lit by dipped sunshine, prevents the image from being entirely blue. Images in which a single colour dominates can be very effective. The blue here works because it is representative of the watery environment, and it heightens the cool aspect of the grey slate rock.

Twilight is obviously a good time to make blue images. Some people might be tempted to 'correct' the colour bias of this image and make it more neutral, but that would miss the point entirely, as a corrected version would be greyish. In this case the blue colour conveys some of the tranquillity that I felt. The morning itself was still, allowing perfect mirror-reflections on the shallow water. It was also very cold. Perhaps something of this unseen environmental quality is captured in the finished photograph?

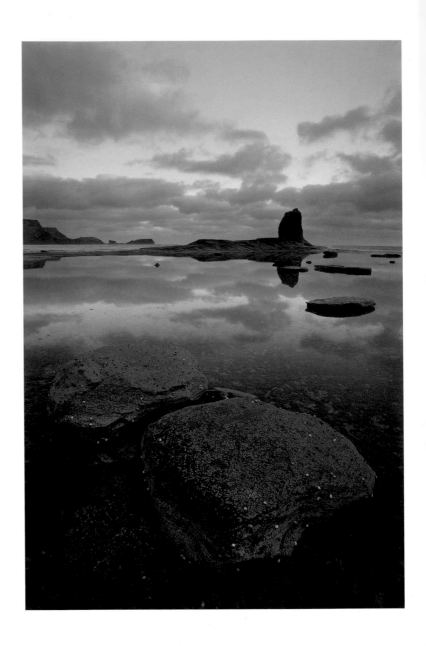

Black Nab, Saltwick Bay, dawn twilight, North Yorkshire
May

Reflection, Scattering and Absorption

All surfaces have different textural properties and these determine how they will react when illuminated. Knowing how surfaces reflect or absorb light will allow the photographer to have more creative control over their subjects. What follows is a simplified overview of how light behaves on contact with different surfaces.

When light strikes an object it can be reflected or absorbed in varying amounts. Most surfaces absorb certain wavelengths then reflect the rest, depending on the material. In the realm of light there are two types of reflection: first, specular reflection, which is best illustrated by a mirror. When light hits a smooth surface, wavelengths bounce off following parallel trajectories. The ordered reflection is responsible for the 'mirror-image' seen on still water.

Secondly, there is diffuse reflection, also known as scattering. When light strikes an uneven surface, the reflected wavelengths bounce off in random or 'scattered' directions. Most objects exhibit both types of reflection, relative to their degree of smoothness. Scattered light determines an object's apparent colour. A leaf appears green because it absorbs all wavelengths apart from green which it scatters, so this is the light colour that reaches our eyes.

The blue colour of the sky is due to a process called Rayleigh scattering. In bright sunshine atmospheric gas molecules are very effective at scattering violet-blue wavelengths, while the longer wavelengths pass through unaffected. This scattered light, or skylight, reaches us from all directions and the sky appears blue. It does not appear violet-tinged because human vision is more receptive to blue. When looking towards the sun, the non-scattered light appears intensely bright and slightly yellow by comparison. Without the effect of Rayleigh scattering the sky would appear black.

Finally, dark colours appear so because they absorb more light wavelengths than pale colours do. A pure black object traps all the light it receives, therefore there is an absence of reflected light. A pure white object reflects all wavelengths of light equally, absorbing nothing, so we see white.

Rhossili beach at twilight, Gower, Swansea
June

In low-light conditions any reflections are helpful. In this twilight expanse a large area of wet sand reflects the sky's luminosity, elevating what would otherwise be a dark foreground into a functional and interesting part of the image. Notice that the ebbing sea exhibits less specular reflection than wet sand; the sand's smooth surface provides a better mirror.

The beach, composed of pale sand grains, is capable of reflecting a small proportion of the available light, making this area distinguishable from the dark rocks, even in fading twilight. I would not have paused to take this photograph had the area of wet sand been absent or if the light conditions had become so low that there was hardly anything to reflect. It is this area of brightness that draws the eye; without it the image would appear flat.

Seilebost, rippled reflection, Isle of Harris
September

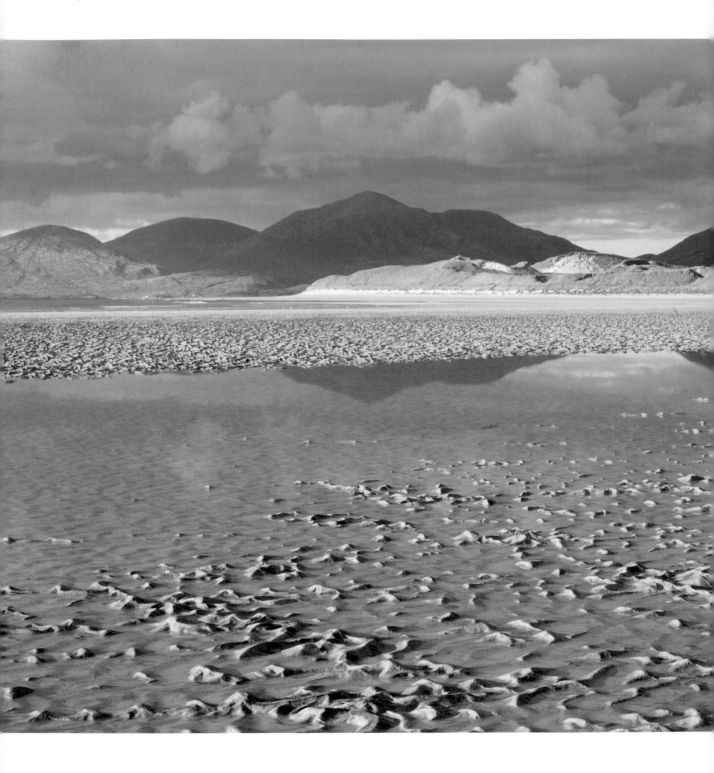

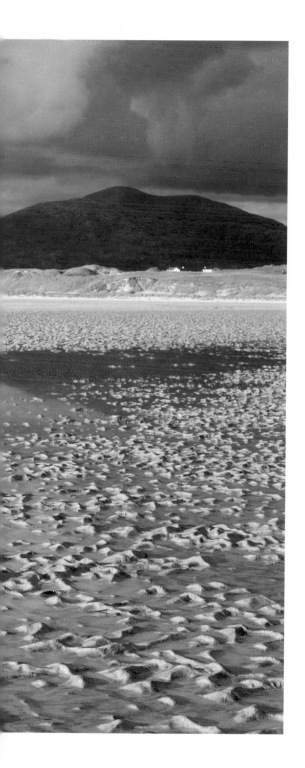

In this age of digital possibilities, the effects of many photographic filters are easily reproduced at the processing stage. However, the polarising filter's effects cannot be recreated post-capture, making it as important as ever. It is used to control the amount of reflected light entering the camera, an action that has major implications.

One use for the filter is to reduce surface reflections on water, allowing a total or partial view of whatever lies beneath, depending on the lighting angle and the degree of polarisation. In this photograph, it has been used to lessen the reflection only slightly, making it is just possible to see the sand-ripples below the water's surface. If the filter were rotated round only a fraction further then the mirror image of mountains would disappear altogether, creating a very different scene.

The scattered light that makes the sky blue can also result in it appearing 'washed-out'. Fortunately the filter helps with this problem, making the sky a deeper and more intense colour. Impact is strongest when the scene is bathed in bright light arriving from a 90-degree angle but is absent in overcast conditions. The effect also depends on which area of the sky is being photographed, as the sky nearer the horizon is less affected than the sky above.

Micheldever Wood, dappled light, Hampshire
May

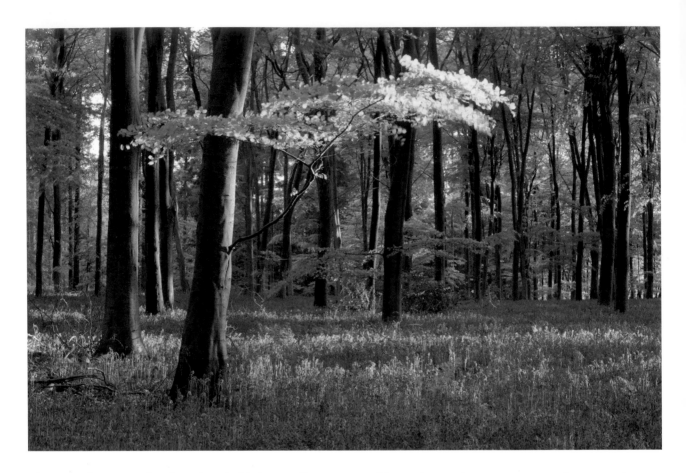

Photographing woodlands in dappled light usually causes problems due to the contrast range between deep shadows and highlighted areas, a tendency that is exacerbated by shiny surface reflections on vegetation. The stronger the sunshine, the more 'washed-out' and bright everything becomes, to the point where 'true' colours are hidden beneath a silvery sheen. Some of this problem is avoided by working in the early or the late part of the day, but even when light is less intense reflections are still apparent.

This is another case where the polarising filter can be used to control surface reflections and it has two important effects: first, it takes some of the intensity out of highlights, bringing them into balance with the surrounding tones, and second, colours appear much more saturated as the sparkling haze is eliminated. Both these qualities help to produce well-exposed and vibrant photographs, making the filter an indispensable tool.

Magic Hours

The nature of light changes considerably over the course of the day. Factors combine to make sunrise and sunset arguably the most interesting times of day to create evocative photographs. The powerful symbolism attached to the beginning and end of the day should not be overlooked. First light at dawn signals emergence from night into a new day, and the darkness of night is never far from the fiery last gasp at sunset. Perhaps in this age of electric illumination, recognition of this cyclical event is less potent than it once was, but I challenge anyone to deny the emotional significance of an impressive sunrise or sunset.

What causes this time of day to be so special? First, because the position of the sun in relation to the horizon is at its lowest at the beginning and end of the day, lightwaves travel further to reach us than when the sun is directly overhead. As light travels this longer path through the atmosphere, violet and blue wavelengths are scattered to the point where they are no longer in the line of sight, leaving the orange and red wavelengths dominating the visible light. A red sunrise or sunset will have a temperature in the region of 2000°K, similar to the colour of a candle flame. However, this warm light soon cools, changing significantly within the first hour of the day.

Second, the intensity of sunlight is greatly reduced at sunrise and sunset. On a clear day, when the sun is at the horizon, the light levels are around 400 lux. Light levels change quickly: the period after sunrise at the height of summer when the light retains this special quality, is much shorter than in midwinter, when the sun remains lower in the sky throughout the day.

Another factor influencing the vibrancy of sunrise and sunset is the type of cloud cover. The best possible scenario is the presence of mid-level to high-level cloud that reflects light's colour, increasing the desirable spectrum of pinks, reds and oranges. A rare but wonderful sight is when a gap appears between the horizon and a low-level cloud such as stratus. In this instance as the sun rises or sets, the gap glows vividly against dark clouds cast into shadow. If there are no clouds from which light would reflect, the colourful effects are less obvious. On the other hand, too much cloud in front of the sun results in insipid colours that have little impact.

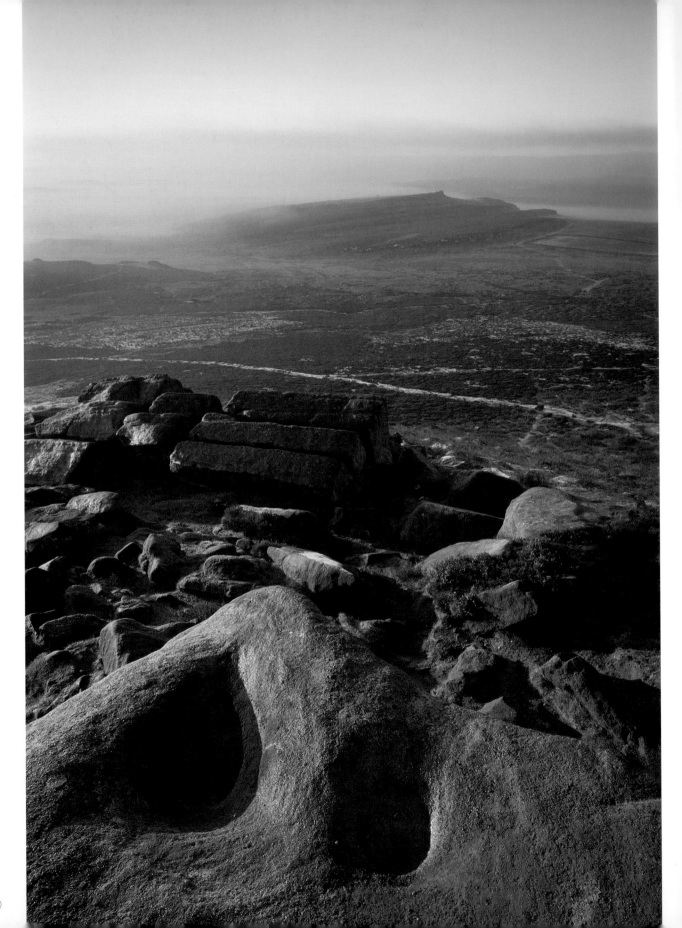

Sunrise

Millstone Edge from Higger Tor, South Yorkshire
December

In the dark of a December morning, I awoke to cloud that thickened into dense mist as I descended into the valleys near home. There were two choices, to stay at my chosen location and hope that it would lift or to climb higher. Instinct told me to go higher and it proved well worth while. Walking over the hill outcrop at Higger Tor, the mist began settling downwards into the valley below, allowing the first watery rays to penetrate through the clouds. As the sun's effect grew stronger the mist started to burn away gradually, leaving some areas of landscape cloaked while others were revealed. The colour of the light at this time, just minutes after sunrise, was a beautiful pale gold. Not brassy as with some sunrises and sunsets, but with just a hint of warmth that perfectly highlighted the dark sandstone.

Side-lighting was the best choice for this shot, as the shadows it created were long and soft, filling in the strange eroded hollows and defining the scattered blocks. Each sand particle glints in the raking light, the rock's rough texture made apparent by each grain's small but significant shadow. Side-lit mist also glows with delicate subtlety, retaining the light's warm temperature. In the distance, where the landscape is not yet directly illuminated, the mist is blue as it reflects light from the sky.

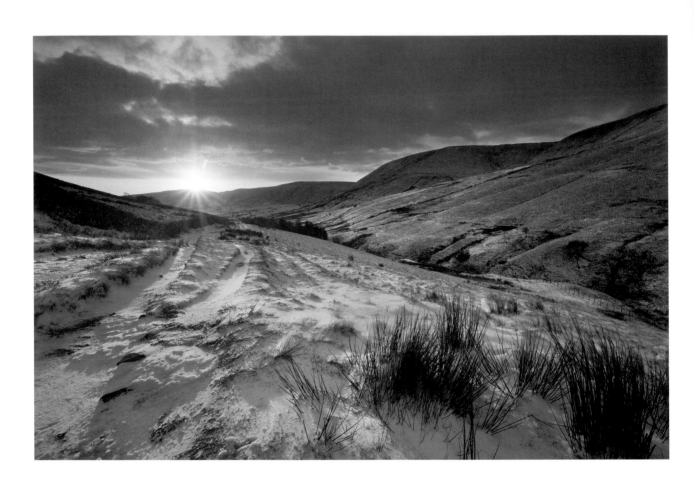

Upper Booth, The Pennine Way, dawn, Derbyshire
February

Pausing on the ascent of Kinder Scout to look back down the track from Upper Booth, it seemed that the sun was finally about to emerge from behind Rushup Edge, some minutes after the actual sunrise time. Because of this short delay, the initial vibrant magenta colour at dawn had dissipated slightly, but the light was still a pleasant warm pink. Sunlight striking the underside of well-placed clouds created a pale peach glow against the shaded sky.

Low-angled back-lighting reveals shapes and contours within the landscape, giving them heightened presence. Fresh, undisturbed snow reflects the warm light beautifully, contrasting with the long cool shadows. The only reason it was possible to shoot this scene back-lit was due to the snow layer acting as a giant reflector, otherwise the moorland would be in partial silhouette, appearing as a flat dark area against a bright sky. The snow lifts everything it touches with glistening highlights and rich colours that help to balance the sun's intensity.

Loch Ba, Rannoch Moor, sunrise, Highland
September

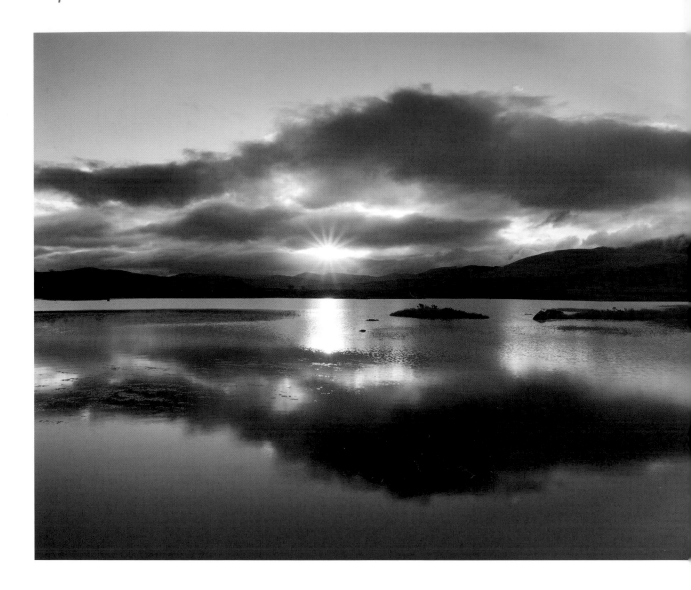

It was a chilly early autumn morning and Rannoch Moor was painted with the blue palette of scattered skylight. A small proportion only of the light was coming directly from the newly emerged sun, meaning that the primary illumination was diffuse, ideal for photographing water. The subtly lit water and sky provide excellent contrast with the sunburst appearing through the clouds. The effect of reddish light creates a barely perceptible warm colour in the white clouds. Strong surface reflections mirroring both the sun and highlighted cloud edges enhance the range of illumination.

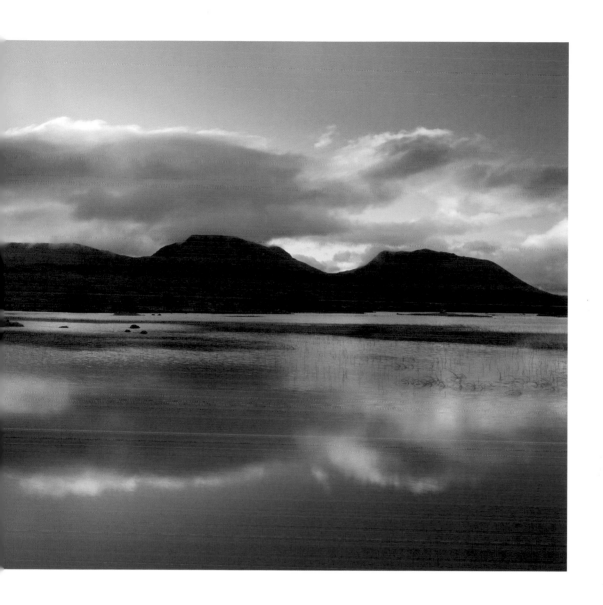

Wind blowing unevenly across the loch caused certain areas to appear rippled, scattering light across its surface, which accounts for the absence of mountains in the reflection. Although setting out with the intention of photographing a perfect mirror of the landscape, in reality it was not possible in the prevailing conditions: low light, rising wind and long shutter speeds.

Sunset

Dunes and bird tracks, Freshwater West, Pembrokeshire
June

This image was recorded when the light's colour temperature had just begun to shift from the warm yellow of late afternoon light to the beginnings of what was to be a pink sunset. The sky was still radiant blue and the clouds were white, as they had yet to be affected by the colour change.

Initially exploring the effect of side-lighting, it noticeably reduced the impact of the interesting grass shadows. Back-lighting was also unsatisfactory because it meant looking into the glare of the sun, making the sky appear washed-out rather than blue. Situated half way between these two options, the best angle to achieve balance between these concerns was 45 degrees to the sun, revealing the lengthy grass shadows and keeping glare to an acceptable minimum.

It would have been preferable to see the blush colour on the dunes deepen, however, from this position the large sand dune's encroaching shadow threatened to swallow up the illuminated foreground. In the few minutes it took me to find the camera position and set up the equipment, the shadow had crept forward by several inches.

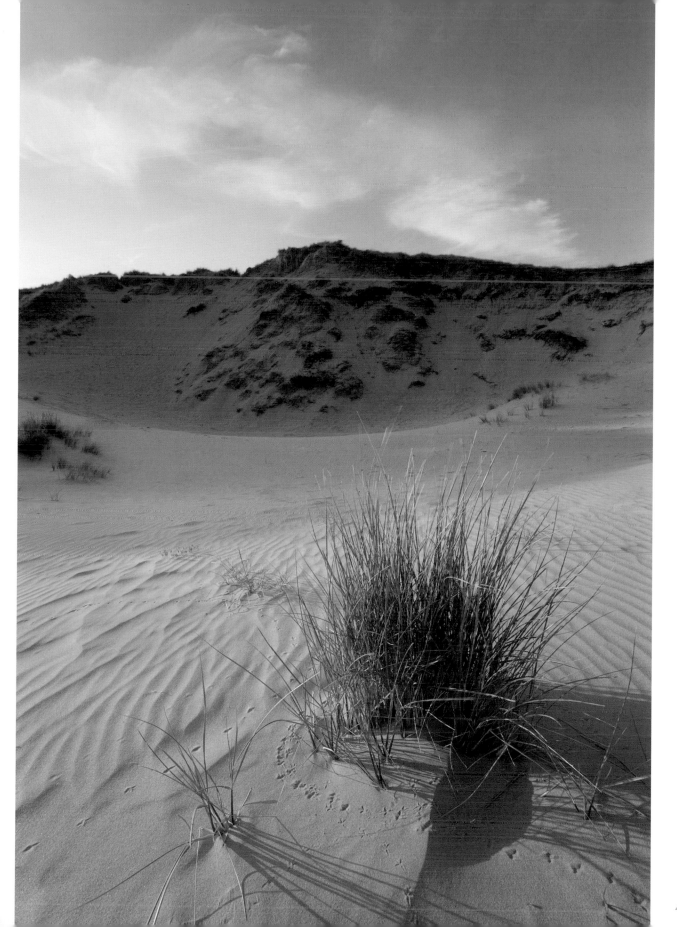

Last light, Llanberis Pass, Gwynedd
June

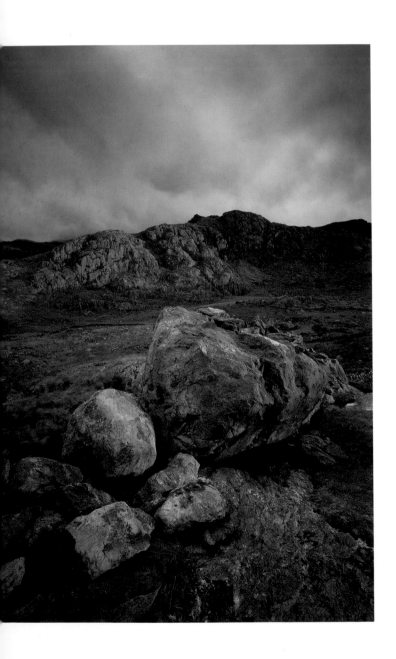

This intense pink colour was evidence of the sun's very last rays on a stormy day. Wind turbulence constantly battered both camera and me but patience was eventually rewarded with vibrant sunshine lasting less than a minute before sinking below the horizon. The light escaping from the cloud layer was almost blood red, a colour possible only with the right kind of cloud in the appropriate position.

A primarily dark landscape with a highly concentrated amount of light meant using a shutter speed of several seconds to record the correct exposure. Not ideal with gale force winds seemingly trying to uproot the mountains themselves. The lengthy shutter speed is seen in the blurry foliage next to static rock and in the softness of fast-moving clouds.

The most important aspect here was timing, the light becoming more vivid in stages. There was no point in pressing the shutter too soon as the light had not reached full intensity. Although pressured and tense, I was able to concentrate enough to take this shot at the moment it seemed the light would not get any better. This was an instinctive reaction based on a reading of the weather conditions. Much practice has made it a little easier to predict the weather's next move.

Balnakeil Bay, setting sun, Sutherland
October

On a crisp and mostly clear autumn afternoon, circumstances combined to produce vivid orange light in the minutes before sunset. The entire landscape was suffused by the warm glow, which was strong enough to transform simple elements into a dramatic image. I concentrated on the shining wet sand, sparkling highlights making the range of tones more dynamic and adding visual impact. In most scenes the sky is bright and the land comparatively dark. However, in this case, light reflecting off wet sand brings these two areas into balance, making them almost the same tonal value.

Although the sun was low, it was still blinding so I waited for it to dip behind the hills. The almost obscured sun has the additional benefit of creating a starburst effect reaching out from the horizon. Fluffy cumulus clouds reflect some of the lingering light wavelengths, making the colours of the sky a little more intense and the space more interesting.

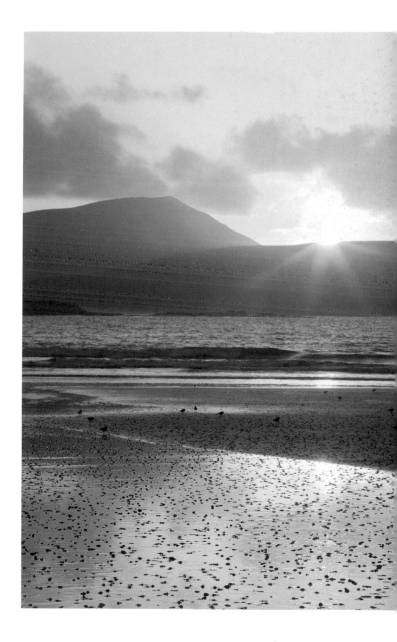

Colour

The human eye has three cone types, each one attuned to short, medium or long wavelengths, translating light into a myriad perception of colour. The individual functioning of these cones allows discrepancies to exist between us. Non-functioning or absent cones cause varying types of colour blindness; by contrast, evidence suggests that a very small percentage of people have an additional type of cone which, theoretically, expands the range of perceptible colours.

An interesting feature of colour is the effect it has on us emotionally and the way it has shaped descriptive language, for example: 'red hot' and 'feeling blue'. It is a sweeping generalisation to assume that blue equals sadness to all people, but there does seem to be a consensus view that it is a subdued colour. It is as much associated with deathly cold, as it is with peaceful pools reflecting the sky. Red is so often used by nature to indicate toxicity, and has passed into general use as the standard hue for warning signs and stop signals. Representing fire, molten lava, blood and passion, it is the most active colour. Green is the primary colour of photosynthesis and vegetative growth, transforming the landscape upon its annual return after the muted colours of winter. Green has come to represent all things environmental, giving its name to a political party and a lifestyle choice.

Much is written about colour symbolism, some of which appears entirely arbitrary and too prescriptive. Colour perception is individual and to a certain extent so are the associations we build with it. How we describe and react to colour varies from culture to culture but it is important to all. We evolved colour vision because it is useful to us, being built into our conceptual understanding of the world.

When learning to paint, children are taught to use red, yellow and blue primary pigments from which other colours can be made. Mixing two primaries makes a secondary colour: red plus yellow equals orange, yellow plus blue equals green and blue plus red equals purple. Mixing a primary and a secondary creates a tertiary colour and so on. However, on my first attempt to print photographs in a colour darkroom, these rules of colour theory had to be discarded. Working with the colours of light meant thinking in terms of red, green and blue (RGB) as the three primaries. As a photographer, RGB is now the dominant colour model I use.

RGB colour model

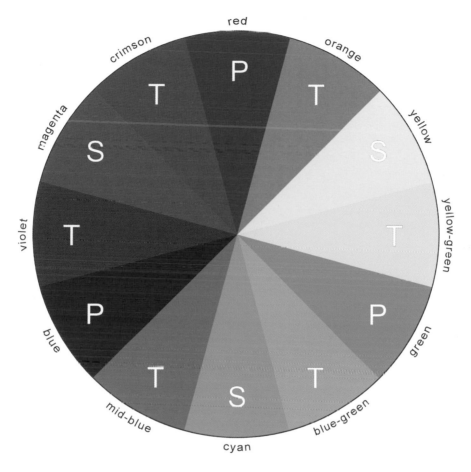

P = Primary S = Secondary T = Tertiary

Why the difference? Combining coloured light wavelengths is an additive process as the more wavelengths are viewed together, the brighter the appearance. Equal proportions of all colours are present in white light. By contrast, mixing pigments is a subtractive process, and adding more pigments to the mix results in a darker colour. Whichever school of thought you have been trained in, it is reassuring to know that the colour models have more similarities than differences. At the heart of both systems is the understanding of colour relationships that are more easily seen when the spectrum is represented as a wheel. The way colours interrelate is complex, but the two key concerns for artists are harmony and contrast.

Colour contrast

Found at opposite points on the wheel, are the complementary colours. Hues the least like one another, providing maximum contrast; yellow is made from an equal mixture of red and green light and blue stands apart. Blue is not involved in the making of yellow so it is diametrically opposed on the colour wheel.

Saturation contrast

Colour impact is affected by saturation; vivid colours jump forward and subtle colours recede by comparison. Colours at maximum saturation are undiluted, dominating those with lower saturation that are on their way to becoming grey. Many would write grey off as dull, drab and insignificant. However a muted hue will form a 'foil' for an adjacent area of saturated colour.

Lightness contrast

Lighter or darker shades of the same hue, for example light and dark blue, are distinguished from one another by their brightness. If they are sufficiently different, contrast will exist between them. Brighter colours are more apparent and darker ones less so.

Colour harmony

Harmonious colours are those that are most alike. Red, orange and yellow are harmonious because they sit in the same area of the spectrum. Red dominates this grouping as it is the primary colour. Yellow is a secondary of red (mixed with green) and orange is a tertiary of red and yellow. Therefore, red, orange and yellow share common traits and exist alongside one another without competing for attention in the way that contrasting colours do.

Considered use of colour adds extra dimension and atmosphere to a photograph. Combining complementary colours create dynamic images, whereas those featuring harmonious colours tend to be subtle by comparison. It is important to remember that you are making images that are personal to you, so use colour instinctively. Some people naturally tend to use limited palettes whereas others are drawn towards technicolour. There is no correct approach but my general rule is that too many colours in one image can prove to be an information overload.

Longshaw Estate, heather birch moorland, Derbyshire/South Yorkshire border
August

Saturated magenta heather flowers stand out next to vivid yellow-green birch trees, two colours that are complementaries. A grey stormy sky is unsaturated enough not to distract from the main subject. Imagine for a moment how it might look with a radiant blue sky. The vegetation's natural vibrancy would suffer next to an intense colour. The dark sky has a bluish tint, contrasting with the yellow-greens, but it is essentially a muted hue, allowing the full saturation of the vegetation to shine through.

Naturally, images like this have to be planned. The location caught my eye about a year previously and was the foundation of an idea that, in theory, sounds like simplicity itself: purple heather, birch trees and threatening storm clouds. The three elements add up to tell the story of a typical upland environment in late summer. When the opportunity finally arrived, I waited, spread-eagled among the heather for half an hour for the storm cloud to fill the correct area of sky and the sun to emerge from between clouds to my side.

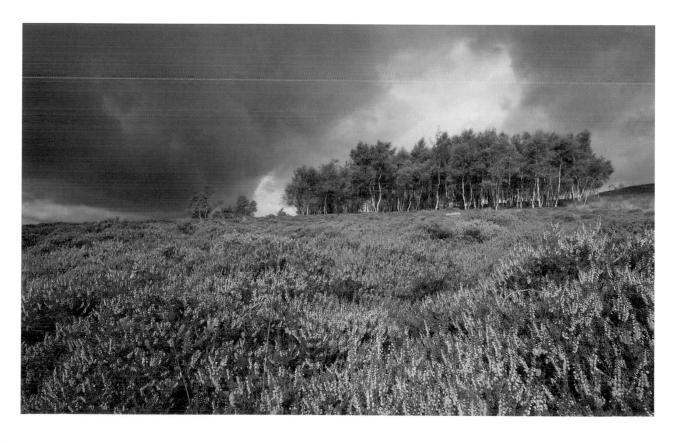

Glen Sligachan and Glamaig, Isle of Skye
September

Taken in early afternoon when the sun's high elevation results in shortened shadows, the landscape is almost entirely bright, the exception being a large shadow cast by a huge mountain mass, without which the landscape would appear virtually flat. Consequently this image is staged primarily in terms of colour, not tonal, contrast. Fading moorland vegetation takes on an autumnal orange glow made all the more intense by its combination with other colours. The shrubby bog myrtle is framed against the orange backdrop, making it stand out from the midground. If the moorland were green too, no distinction would occur and the shrub would merge into this area.

A most striking juxtaposition exists between land and sky, mid-blue being the complementary of the orange vegetation. All three primary colours of light are represented here, creating a broad rainbow-like spectrum. Saturation has been boosted by using a polarising filter, at 90-degree angle to the sun, reducing reflections caused by harsh light. Because this photograph was taken in reasonably neutral-coloured light, 'normal' hues are portrayed in the landscape. The colouration would be markedly different if taken earlier or later in the day.

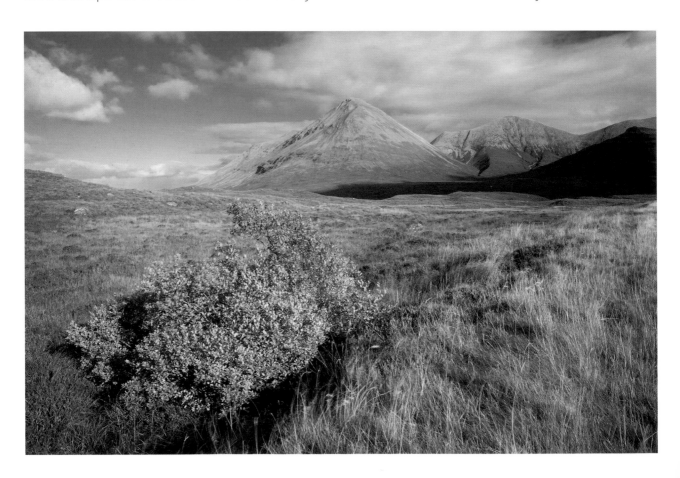

Bamburgh Beach, reflected sky, Northumberland
September

As the rising sun slowly seeps through the low grey clouds hugging the horizon, an intense glow begins to spread across the sky. However, as the sun is still mostly hidden very little direct light reaches the ground; instead diffuse skylight provides the main source of illumination, bathing everything in soft blue hues and producing subtle mauve tints where warm and cool light sources mix.

Cool blues and purples are peaceful and receding colours that are quite at odds with the shock of attention grabbing pink in the eastern sky. Even though it is a small part of the overall image, the vivid pink is the dominant presence and the eye is immediately drawn to it. The deliberately sparse composition uses reflective water advantageously but is otherwise just a simple framework, allowing the natural drama of emerging warm light to take centre stage.

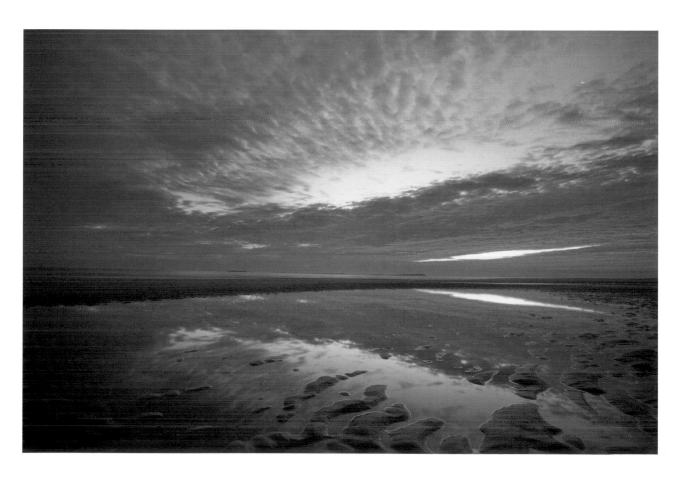

Light and Shadow Depth

Photographs are a flat representation of a world that our brains translate as three-dimensional. Arguably the biggest challenge facing the photographer is how to include a sense of spatial depth in a two-dimensional format. There are ways of creating the illusion of depth in an image, many of which are related to composition (more on this in the next chapter). The other major factor that reinforces perspective is the balance of light and dark areas. Using side-lighting will lend 'body' to a scene as the gradations of tone reveal shape and form. Combine this with an object's cast shadow, and any brightly illuminated areas will assume heightened presence due to contrast. This fact can be creatively manipulated to suit the composition in mind, as bright tones jump forward in the frame, while dark tones recede.

The eye is attracted to luminous areas first and foremost. If, for example, there is large area of bright sky included in a photograph, the rest of the scene will be diminished, which might not be what the photographer intended. Another way of applying this principle is in the selective use of light. If cloud shadow combines with pools of illumination, it would be better to wait until the most important element in the image is in the spotlight, thereby highlighting its significance.

A small bright object in a dark background will appear very different from a small dark object in a bright background. Think of the crepuscular ray, the beam of light

that escapes from cloud edges, which selectively illuminates part of the scene. The natural contrast has high dramatic value. If there is too much brightness, such as when shooting in full and direct sunlight, the scene appears washed out as tonal contrast is reduced. If everything is of a uniform brightness or darkness, the image is potentially bland. It is the balance of tonal extremes that brings a photograph to life.

Highlights and shadows are self-evident as these are at the extremes of the tonal range. Less immediately apparent, but equally important, are the shades of grey in between. Most images are primarily composed of grey tones, the middle point of the scale is known as mid-tone. Unless shooting in very bright sunlight, a close inspection reveals that shadows are not pure black. Similarly only a very reflective surface, in adequate lighting, will produce highlights that are pure white.

It is important to distinguish between shadows cast by the subject and shadows that are created by clouds, as the latter are bound to move and that will significantly change the landscape's appearance. Of course shadows cast by objects also move throughout the day in relation to the sun's position, but this happens incrementally and you would have to be standing in the same position for a long time to notice this. However, this may well influence the time of day when it is most appropriate to photograph a particular subject.

Duerley Bottom and Dodd Fell, cloud shadow, North Yorkshire
April

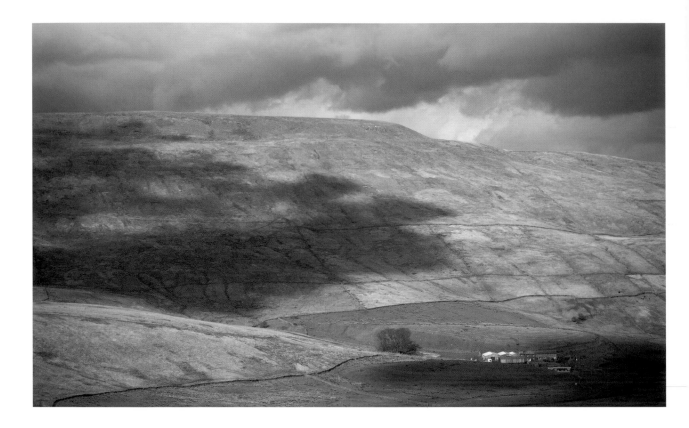

This was a day featuring difficult overcast lighting conditions. When the odds were briefly working in my favour, there were broad sweeps of golden light across the yellow-green moorland vegetation. Although this sunlight was pleasing enough in intensity, it was just a little bit too generalised because the sun was still high in the sky, thus making the landscape appear flat. Fortunately, because of the mountain's scale there were clouds scudding between it and the sun, forming interesting shadows upon its flank. It immediately became apparent that this was the answer; including an element of cloud shadow serves to break up the uniform brightness.

Once the image was composed – taking time to position the apparently minute farm below Dodd Fell's impressive height – it was just a few minutes before the appropriately shaped cloud shadow came into frame. I pressed the shutter at this moment because I appreciated the balance between shadow on the left and also the lower right, where it helps to define the just illuminated farm buildings. This is important, as the farm was so small within the composition, it needed help to be clearly visible. It would have been useless having it in total shadow.

Glen Etive, Stob Dubh and Buachaille Etive Mor, Highland
September

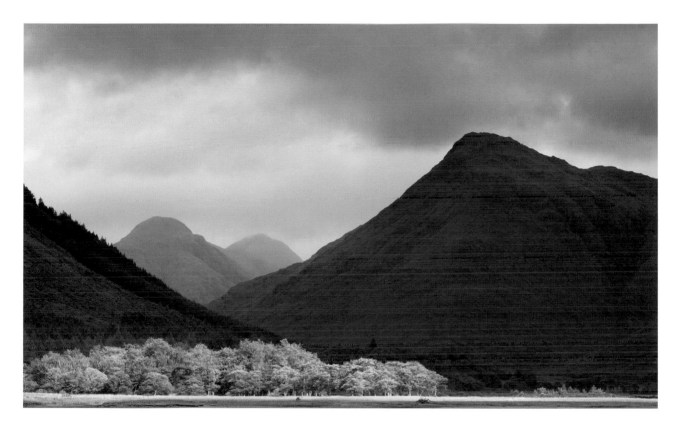

After three hours of sitting around in a beautiful location apparently with little hope of sunshine, slowly the clouds began to move. Narrow beams of sunshine cut across the landscape with knife-like precision. The illumination was just enough to pick out the start of the treeline, isolating a few, which made them seem like a small island stranded against the dark mountain backdrop. This was a perfect example of light appearing in exactly the right place, at almost the right time.

Obligingly there was enough low cloud around to obscure the distant peaks partially. They are still very much a part of the image but their muted presence does not detract from the dominant dark mountain that anchors the composition. Timing was critical here: had I been tempted to press the shutter too soon the light would not have reached full intensity on the trees; react too late and it would have left the trees and be rapidly making its way on up the slopes. Moments like this are tense and after a long wait I can be particularly twitchy, but thankfully patience paid off.

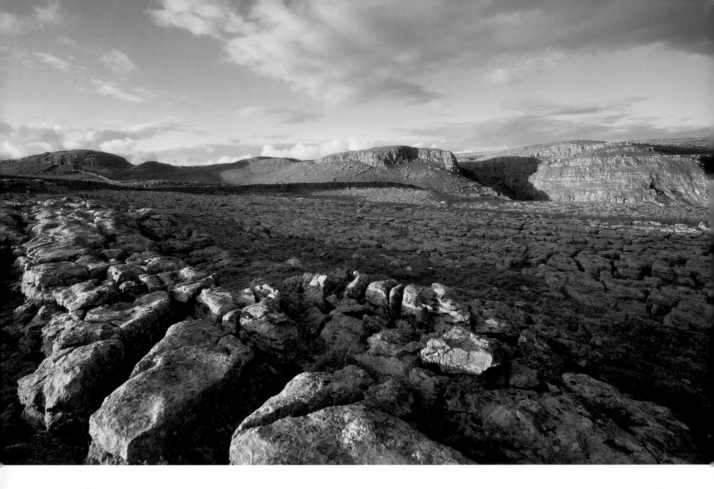

Ewe Moor, limestone pavement, North Yorkshire
April

Low-angled illumination, around twenty minutes before sunset, just catches the upper edges of this limestone pavement on the verge of it disappearing into the shade of adjacent hills. The ground beyond the highlighted rocks falls into soft shadow of considerable length relative to the diminutive height of the rocks responsible for casting the shadow. I have used this natural tendency to my advantage, carefully composing the image to reveal tonal interplay. Because the immediate backdrop is the same rocky material, it is the shadow only that separates the foreground from midground. If the scene had been bathed in more evenly distributed light then these elements would have merged into one another, reducing the sense of space between them.

Another band of golden light stretches out along the cliffs, bringing definition to the background subject. Here long shadows show the scale of the cliffs, revealing their sizeable contours. Once again the shady midground acts as a neutral space, allowing the eye to travel across it unhindered from lit rocks at the front of the frame to the bright cliffs forming the horizon.

Black and White

From an appreciation of light and shadow depth, it does not take long to understand what makes a satisfying black and white image. The short answer is contrast. Monochrome photography is one step removed from the average human perception of the world. Remove colour from the equation and what is left? A collection of tones potentially ranging from deepest shadow to sparkling highlights, flowing through a transition of grey shades. Eliminating colour saturation is the first step on the way to abstraction; it removes one of the reference points used to understand the world around us.

First, if there is natural contrast that can be exploited, such as strong shadow shapes and bright zones, or if there are collections of complementary colours, black and white has a tendency to clarify these elements. Alternatively, I use it for images where colour is not integral to the scene, where colours are muted but there are well-defined structural elements. The latter examples may not have strong natural contrast, but the tonal information can be manipulated to have a greater impact than a colour version of the same image.

There are no rules, however. Generally images that are more towards the contrasting ends of the scale are preferable, rather than images that are too grey. After all it is named black and white for a reason. The preference for tonal contrast is as personal as how we relate to colour. There seems to be an extra quality unique to a monochrome image that is hard to explain. Some subjects that appear decidedly ordinary in colour are transformed when seen in black and white. Perhaps this is because removing colour brings the benefit of simplification.

Uig Sands, dunes on gneiss outcrop, Isle of Lewis
October

As with all my black and white photographs, I initially shoot in colour and do the conversion at the computer-processing stage. This means more ability to tweak tonal information than can be managed in camera – a great advantage for an image such as this, where pleasant afternoon light provided a broad tonal range to play with.

Although this image had its merits when viewed in colour, such as a deep blue sky, its strengths were in the crisp sand textures next to the windblown softness of dune grasses. Also intriguing were the shadows of the grass strands leading the eye into the frame, contrasting with the highly reflective dunes. All in all, the structure of the image was described in tone and texture; colour would have been a distraction. The sunlit sand shines brightly against a dramatic sky darkened using a polarising filter initially then processed to further heighten the contrast.

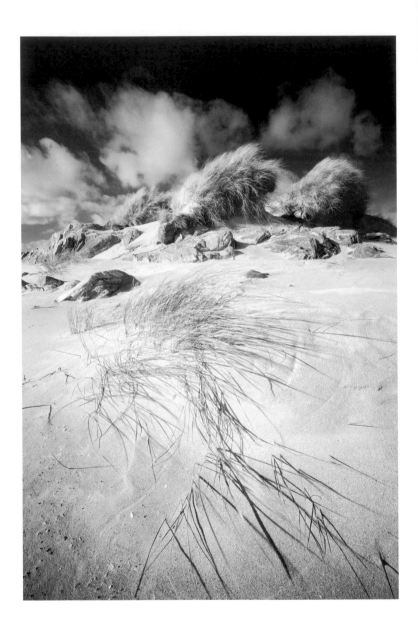

No. 2, Loch Leathen, Trotternish Peninsula, Isle of Skye
September

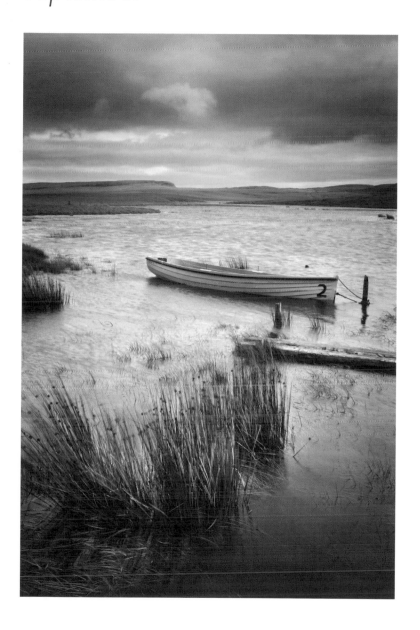

Another grey day on a trip to Skye notable for lashing rain and gale force winds. Returning from an unproductive hike up The Storr, I passed the reflective waters of Loch Leathen, which appeared liquid silver under the brooding sky. Attracting my interest was a small boat painted with a large number '2'. This formed the strong graphic element around which the rest of the image could be resolved.

The only colour extant in this scene was murky greenish-brown sedges and the red number on the boat. Hardly technicolour. Monochrome seems the logical choice when there is subtle tonal variation but a dearth of colour. Contrast between tones can be magnified, heightening forms and textures as it is done. Dark grey clouds heighten the location's bleakness, revealing it in all its glory. It should be stressed that the cloud detail serves a vital function as the image would be a wash-out without the dark and mid-grey tones. An overcast white sky would have caused burnt out highlights in both sky and water, ruining the photographic potential.

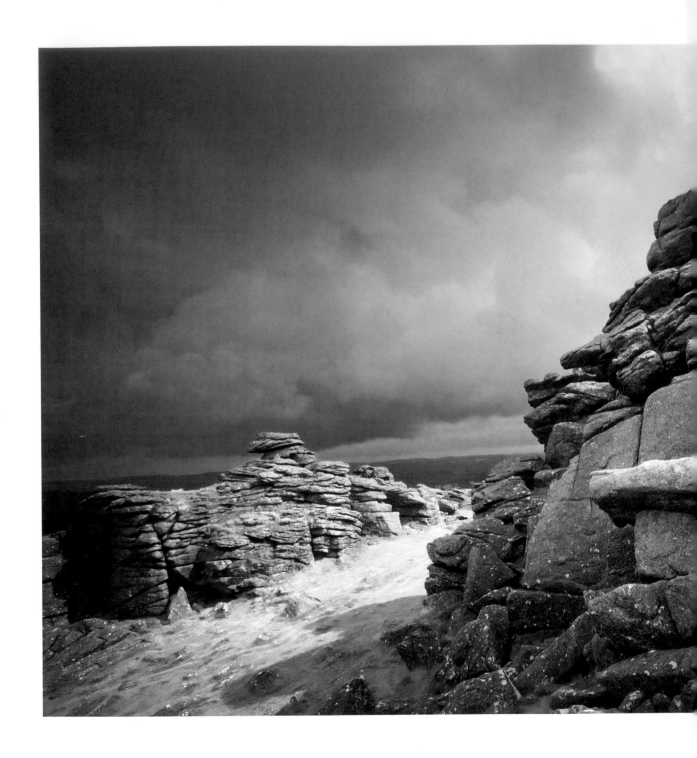

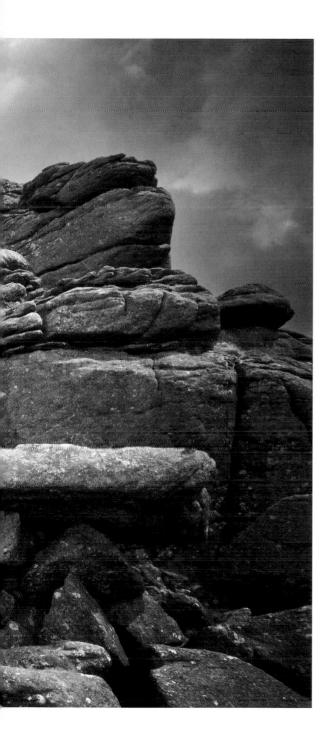

Hound Tor,
brief illumination,
Dartmoor, Devon
September

Photographed on a particularly gloomy afternoon under an oppressive cloud-filled sky with sporadic light patches playing across the terrain, these iconic rock formations assume an eerie presence. This is arguably a scene best captured in stormy weather, as pleasant sunshine with blue skies would undermine the wild atmosphere associated with this exposed location.

Naturally high-contrast lighting is enhanced by the image's conversion to black and white. With colour stripped away, the eye engages more readily with the granite tor's surface patterns. Pure black shadows define erosion-sculpted crevices, while strong reflective highlights on damp grass and wet rocks shine with white intensity. Obvious cloud edges produce a richly textured sky which, originally a slate blue, now touches on charcoal grey. The deeper the tone the more dramatic it becomes and the threat of rain, or worse, is palpable.

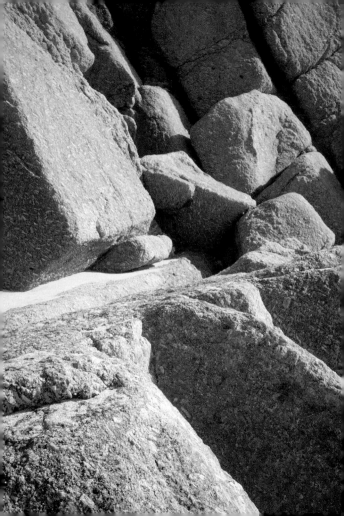

FORM

FORM

There is a creative tension that exists between the reality of the scene in front of you and the collection of ideas that constitute 'artistic vision', resulting in a continuous interaction between artist and environment. I set out to photograph with an open mind, ready to respond intuitively to whatever happens. However, it is important to have a plan: a list of possible ideas that can be applied when an interesting subject presents itself. This extends to imagining the right lighting and weather necessary for a photograph, and when they are likely to occur. I will then go to a location when I think these conditions are possible, accepting that the plan may need to be adapted on arrival. It is far better to work with the situation presented by the natural environment, rather than rigidly setting out to photograph a scene in a preconceived way even if the conditions are unfavourable.

What makes a good photograph? Ask a hundred people and you will receive a hundred different answers. Artistic expression and its appreciation are very personal processes. However, we do share ideas of beauty, from the overtly striking to the deceptively simple, there are certain arrangements that are likely to please the eye. Entwined throughout the creative process is the theme of balance. The interpretation of this abstract quality has engaged artists throughout the history of human culture. The alternative is chaos and disorder, a notion that art has shied away from until comparatively recently.

Photographs are primarily a representative medium. They are at their most coherent when they appear to document the 'real' world. Photography has a power over our imaginations that can only be explained by its ability to document actual places and events. However, this is not written in stone as the camera can be manipulated and the photograph radically altered to the point where it no longer resembles its origin. All images are composed to highlight whatever the photographer wishes to reveal. It is significant that the advent of photography initiated a major conceptual shift within the visual arts. The various disciplines began to move away from precise representation, instead exploring the world of ideas and pure form, ultimately reaching abstraction. This debate about art's role has informed aesthetics ever since.

Our environment continuously bathes us in sensory impressions, resulting in a plethora of information that needs filtering before we can make informed decisions. In the visual world we search for patterns, look for familiar landmarks and cross reference with our mental directory of both nature's and man's design types, picking these significant elements out from a background of seemingly haphazard arrangements. This abundance of subject matter presents an interesting challenge to the landscape photographer and, as nature is apparently random, it often appears chaotic. Include too much disorder in a photograph and it becomes a mess. However, if nature is to be represented faithfully, chaos included, how can this be achieved?

When we look at an object, our focus is on that object. We are not as conscious of the elements existing in the space around it. This is unlike the camera, which will record everything within range, leading into the trap of including too much information in one image. In that first interaction between artist and subject, a decision needs to be made: selecting the most important elements and arranging the camera so as to eliminate any possible distractions.

This whole process starts with the simple, yet obvious, questions: What are you photographing? What is it that interests you about this subject? Why did you stop to look at it in the first place? Thoroughly describe it in your mind and then let that analysis inform your approach. As your relationship with the subject intensifies, insight will deepen. This takes more than a cursory glance; the long and thorough gaze brings the less immediate aspects to light.

Once you have decided why the subject appeals, the next stage is to communicate that interest to someone else. This can be broken down into two stages. First, take the time to decide what the subject's characteristics are and look at its structure. What material is it? What colour is it? What shape is it? Does it have an interesting texture? And so on. Having defined these real properties, the next step is to think about composition. This is very much influenced by your personal preference, your unique interpretation of the world, but it might be helpful to work through a mental checklist of techniques developed throughout the history of visual art. Creating an image is like following a recipe, albeit one where you change the quantities and freely substitute the ingredients to your own taste.

Structure

Structure is what holds an image together; without form it dissolves into obscurity. The essence of seeing the environment is being able to strip it back to its bare bones. Relating what is in front of you to concepts such as lines, shapes, patterns and textures provides an explanation of the landscape's physical facts. This list of structural properties draws heavily on the language of geometry and maths, but to categorise it solely as a formal analysis would be to miss the point. This is where 'art' starts to creep in. How do these arrangements make you feel when you look at them? Why is it that one shape is more pleasing than another?

When interpreting the landscape's patterns, it can be hard to process the overwhelming quantity of visual information. This is especially true of the large vista that seems full of endless possibilities. There may be a dizzying mixture of different structural elements, all vying for equal attention in the photographer's mind. Developing awareness of your primary impressions makes decisions easier. This intuitive response, the 'gut feeling', is a natural facet of human consciousness. Have the confidence to allow this reaction to inform your initial approach, then it can be subjected to more analytical principles, offering the best of both worlds: a blend of both insight and technique.

When arriving at a location for the first time, do not immediately reach for the camera. Spend time looking around for points of interest, trying to work out what the environment's features are; listing them in order of importance, as if forming a synopsis for the story that you would like to communicate. Pause to see how the ambient light affects the scene, and predict how that will change as the day progresses, while correlating what is in front of you with structural concepts.

Lines and Intersections

Lines serve the function of dividing space; they compartmentalise, forming shapes that make a space more visually engaging. The greatest interest can be where lines converge, collide and cross over creating points of tension that concentrate attention. It is helpful to imagine a scene with a grid of squares superimposed over the top, then it is easier to see which way lines are oriented. Diagonal lines that cut across the grid from corner to corner, and curves that meander around in space are usually more dynamic than straight lines, which are rarely found in nature. They are more associated with the man-made environment, featuring perpendicular walls and right-angled corners. Having said that, the landscape is full of flat horizons, too many of which can become monotonous.

A line that extends from near where the photographer is standing into the rest of the space can be described as a leading line. If a landscape element has this property, it can be used to help the viewer navigate through a scene, encouraging their eyes to follow a suggested route. Indeed any line that serves to connect the spatially distinct zones of foreground, midground and background, can be said to lead from one to the other. There is much discussion among artists as to whether images work better when they lead from left to right, relating to the way we read text in the western hemisphere. When I started to think about this and retrospectively apply the idea to some of my own images, I found numerous examples that featured a strong left to right bias. However, I also found many that did not fit with this trend and they do not suffer for it. More importantly than where the line originates is that it should lead somewhere, allowing the viewer to travel back and forth between different regions.

Path from Danebower Quarry, Cheshire
April

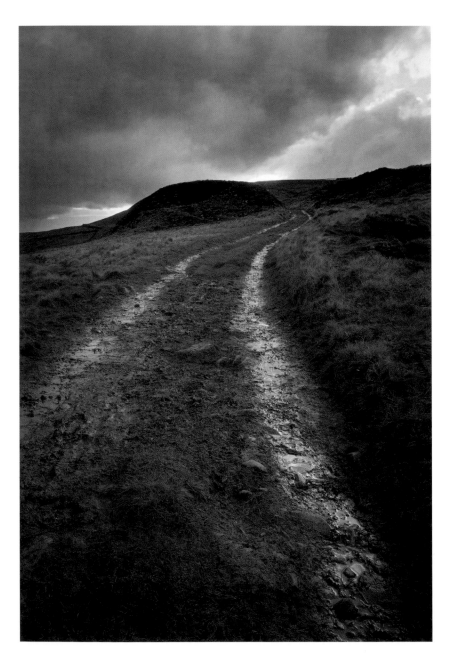

A path is obviously linear and can be used in a very descriptive fashion. It shows the way people have already walked through the landscape. When using a strong line, it is important that it should lead into the frame – not out. That way the viewer's attention is directed towards the middle, not distracted away towards the edges.

In this instance the track's presence was initially unclear because diffuse light conditions resulted in minimal tonal contrast. I struggled to make anything of this scene until a small gap in the cloud layer allowed enough light through to achieve reflective highlights on the wet track. As the puddles gained in brightness and clarity, a clear line of diminishing perspective was formed, terminating at a rise in the hill and leading the eye to a precise point. Instantly my position in space was connected with the near distance, adopting a viewpoint that was a compromise between seeing the path's curving aspect and maintaining alignment from the frame's bottom right-hand corner. A slight move to the left and the line appeared too straight, a pace to the right and the line began to merge with the grass bank at the right-hand side.

The distant mountains were the first part of the landscape to attract my attention but from where I was standing these were more than 3 miles away across Loch Scavaig. However, there were interesting features on the shoreline, deeply incised rocks formed various patterns, some of which led the eye across the water to the jagged mountains. This linear element was too good to exclude.

In the fading light, wet rocks took on a metallic sheen, lifting dark grey granite with pink highlights from the setting sun and contrasting with dark shadowy clefts. Manoeuvring the camera position around until the strongest line led into the scene from the bottom left-hand corner and placing the peak at the top right enhanced the composition's diagonal alignment. The dominant impression is one of being directed from the bottom left to the top right, from foreground to background, thus linking these elements across the liquid void existing between them.

Elgol, Cuillin ridge from granite shore, Isle of Skye
September

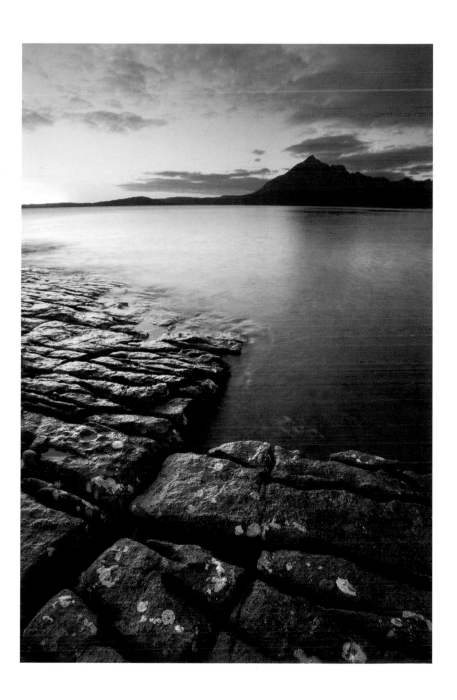

Fields next to Moorside Farm,
below Birchen Edge, Derbyshire
February

This photograph's theme is the pattern created by intersecting lines and the spaces existing between them. Most apparent are the rectilinear field enclosures, golden light uncompromisingly picking out these man-made structures. This image also features a more subtle suggestion of lines. If the concept is broadened to include bands of similar colour or tone, then these can also be used to define space. Contrast exists between the stripes of different colours, pale green frosted fields and birch trees crimson with rising sap.

Returning to the grid idea, this image features mainly horizontal components, making small, vertical details such as trees trunks important. The field walls are viewed from an angle, none of them appearing square-on. The enclosed spaces are more akin to interlocking parallelograms rather than rectangles. I cropped the composition in camera to emphasise the triangular space in the closest field, forming a subtle pointing-shape to direct the eye into the rest of the image.

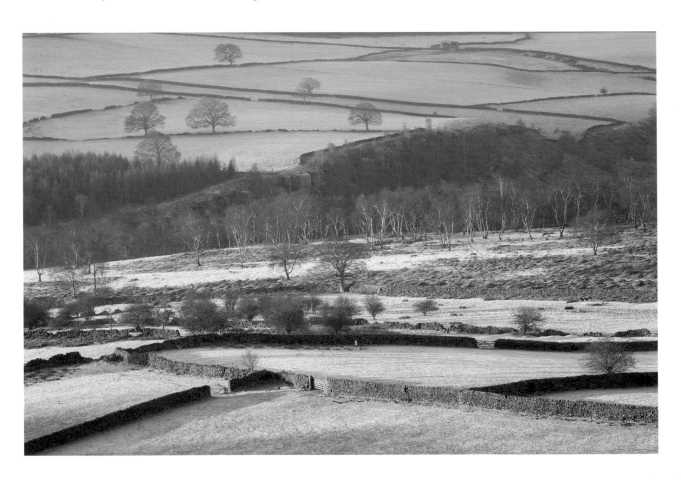

Geometric Shapes

Nature does not usually produce perfect shapes, at least not on the large scale. However, at the smaller end of the spectrum it is a different world altogether – for example, the principles forming cellular structures are responsible for the tessellating hexagons of the honeycomb. We compare these forms to the idealised notions of geometry. These many-sided shapes (or one-sided in the exceptional case of the circle) are instrumental in the way we learn to think about our environment. When presented with a choice between an irregularly-shaped boulder and one that is roughly spherical, the one with rounded edges is more satisfying. It holds the attention because it triggers the pattern-recognising part of the brain, registering as an identifiable likeness.

Regular, defined patterns form strong elements for inclusion in photographs; they bring a sense of order to the background noise of arbitrary configurations. By searching for recognisable shapes providing distinct points of interest, the boulder is not just any old piece of rock, it is a pleasing object in the round and with clear dimensions. Much time is spent weighing up one subject against another as the more perfect its proportions, the more of a pivotal role it can play in the construction of a balanced image.

Rannoch Moor, Stob Dearg and bog, Highland
September

Ask a child to draw a mountain and you will probably be presented with a more or less triangular peak. After all mountains are triangular, are they not? Mountains, like many things around us, have been simplified to a kind of graphical shorthand, reducing everything to sketch form – a series of lines revealing the fundamentals of that object. The vertiginous triangular peak fits comfortably with our feel for geometric shapes. Stob Dearg, the highest point in the Buachaille Etive Mor group, conforms more closely to this idealised design-type than any other mountain I have ever had the pleasure of photographing. That no doubt contributes to it being one of the most photographed peaks in the British Isles.

When approaching a subject on this scale, viewing position is everything. Seen from the east the mountain appears at its most shapely but from other positions the triangular profile is less pronounced. While moving about trying to find a vantage point, I stumbled across (and very nearly into) this boggy pool. The reflection of bright sky on water serves to break up the tonal similarity of the moorland. To emphasise the peak's almost symmetrical form, the tip is placed along the vertical line that divides the frame into equal halves.

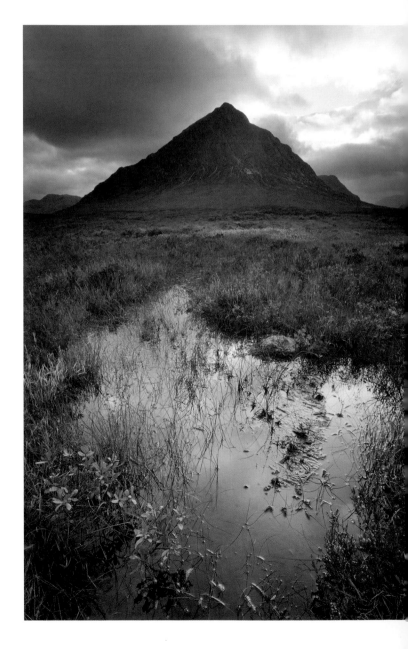

Mangersta beach, grass circle, Isle of Lewis
October

It frequently pays to look out for the small details within the larger scene. As the sun climbed higher towards noon and the light became garish, I turned my attention away from shooting broader views. As my eyes explored the sandy beach, these windblown patterns created by dune grasses stood out. Where they made contact with the sand, the grasses traced sweeping arcs. Inspired, eventually I found this faultless circle.

Nobody can draw a precise circle unaided and yet here was nature doing exactly that. A blade of grass inscribing a circle's circumference, as if set out with a compass. Side-lighting arriving from a fairly high angle gives the appearance of a sundial indicating about four o'clock, a strangely beautiful example of nature's accidental creativity. To convey the inherent balance within this subject, I positioned the circle centrally within the viewfinder, scarcely daring to exhale as I did so, afraid of interfering with the ultimately temporary arrangement of sand grains.

Pebbles and rocky shore, Lavernock Point, South Glamorgan
July

Rock's comparative solidity and resistance to sudden change allows erosion to have an incremental and lasting effect. Wind, water and ice exploit the natural weaknesses of the differing materials that make up the many rock types, forming fissures, detaching it and weathering the remains into characteristic shapes. Occasionally eye-catching patterns are produced, providing striking evidence of this slow destructive process.

The platforms of lias limestone sited under cliffs at Lavernock Point are like an extensive geometric jigsaw. Cracks divide the terrain into an interlocking lattice where no two shapes are the same and meet at random junctions. This in itself would make an interesting photograph but it has more impact when considered in context with pebbles of the same material. Tumbled by the sea, the ovoid pebbles spread across the linear pattern causing a subtle visual juxtaposition of smooth next to angular. The contrast reveals more of the landscape's story than it would if the cracks in the platforms were photographed alone.

Symmetry and Asymmetry

Nature's forms can be clearly divided into two groups: those exhibiting symmetry and those that do not. The principles of either symmetry or asymmetry govern all arrangements from interactions between atoms to the largest forms within the universe. It has recently been accepted that the universe itself exists due to asymmetry, owing to the fact that there is more matter than anti-matter, which makes life as we know it possible.

It is interesting to note that we implicitly respond to symmetry because our brains are hard-wired to identify repeating patterns. We are imprinted with the ability to interpret faces from the moment we are born. Human faces are a good, but by no means perfect, example of symmetry. Duplication, or mirroring, is a pattern we cannot help but notice. Asymmetry is defined as a lack of symmetry and the want of a distinct pattern is a non-event. Because asymmetrical forms are apparently random, and without obvious order, we do not on the whole invest the same level of significance in them.

Llyn y Gadair, reflections of Cadair Idris, Gwynedd
July

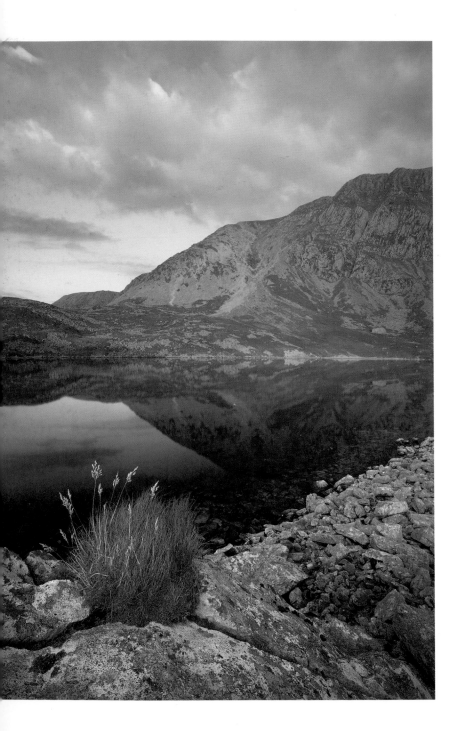

This small lake nestles below Cadair Idris' summit, the bulk of which is providing shelter from the breeze on this occasion. Its still surface shows perfect reflective symmetry, the mirror illusion being especially strong along the line where water and land meet, appearing almost unreal. It is an impressive experience to see exact symmetry displayed so boldly in nature on such a large scale. The repeating pattern demands attention and even inspires awe.

In order to capture the reflection at its best, timing was key. Owing to fading light as sunset approached, a relatively long shutter speed was required to record the correct exposure. This meant taking the shot in between light breezes, as even the gentlest gust would have created ripples, compromising the effect. Despite the powerful mirror-symmetry, the image is asymmetrical overall due to inclusion of foreground rocks, which I deemed necessary to provide a sense of depth. However, it is not the rocks to which the eye is drawn as they are overshadowed by the reflection's significance.

Manners Wood, rowan sapling, Derbyshire
May

Humans are a good example of bilateral symmetry. We have a left and right half to our bodies, one being a close facsimile of the other. This arrangement appears throughout the animal and plant kingdoms, and is seen in this rowan tree's foliage made up of individual leaflets shaped by bilateral symmetry. Any leaf folded lengthways would mirror itself. A symmetrical configuration also occurs within the leaf's internal structure, as close inspection shows that the veins are arranged along the same lines.

This balanced arrangement affects not only the structure of the rowan's leaflets but also determines their position. The leaflets are found precisely opposite one another in pairs along the stem. The foliage is a pattern within a pattern. Examples of symmetry appear momentarily ordered in an environment that seems fairly chaotic, explaining why these patterns make such strong subjects for inclusion in photographs.

On a grey day when the sun failed to make even the briefest appearance, the combination of diffuse light and uniform winter drab seemed determined to defeat me. Ever the optimist, I carried on up the hill and spotted these two trees, standing like a pair of sentinels. The relationship between their outlines had a trace of symmetry, and although not an exact mirror, it was certainly close enough to make a striking impression. As one tree is positioned closer to the camera, thus appearing larger than the other, the sense of equilibrium is undermined.

My approach was to pare the subject back to its bare elements, allowing the sky's emptiness to form a neutral backdrop for dark, twisting branches. Stark monochrome minimalism enhances the subject's strong form. Trees also exhibit another type of repeating pattern: fractals. Each time branches divide a smaller replica is generated that is similar, but not identical, to the one preceding it. Awareness of pattern opens the mind up to recognising the natural world's structures, for instance the 'branching tree' motif is seen in lightning strikes, river deltas and the human nervous system.

Bleak sunset near Wincle, Cheshire
February

Contours

When walking through the landscape, we feel its undulations beneath our feet. The dramatic peaks and sheer drops that never fail to impress are the contours that give dimension to the Earth's surface. I find myself drawn again and again to mountains and valleys where variations in height and scale have great impact both visually and psychologically. As a rule, I find it much harder to engage with flat horizons. When faced with this eventuality I search for vertical elements to break the pattern, relieving unbroken monotony by introducing a change in direction.

Although contours are most easily illustrated by large landforms, the majority of natural surfaces are subject to changes in gradient. Some of these features are so subtle that they can be seen only in low-angled light, being all but invisible when the sun is directly overhead. Even the smallest contour, such as a ripple on a lake's surface, is a significant feature which can be incorporated in to the larger landscape or, perhaps, simply photographed in its own right. Small-scale details are integral building blocks of the whole scene and should not be overlooked.

Stac Pollaidh, passing shadows, Assynt, Wester-Ross
October

As this photograph was taken in the late morning, the sun had already climbed high enough to cause shadows to contract significantly, rendering the scene predominantly bright. When all is uniformly lit, even a landscape featuring impressive contours and lofty peaks, appears flattened. Objects lose a sense of dimension within their surroundings when they cast little or no shadow.

Fortunately, I did not have to wait long for the unsettled weather to produce sizeable cloud shadows that, as they scudded past, created a degree of much-needed tonal variation. It is these transient shadows that define the landscape's contours. The area at the front of the frame is bright against a shadow directly behind it, which in turn overlaps another bright patch including the image's main focal point, Stac Pollaidh's shapely peak. Layering of contrasting tones divides the space by separating one curve of land from another.

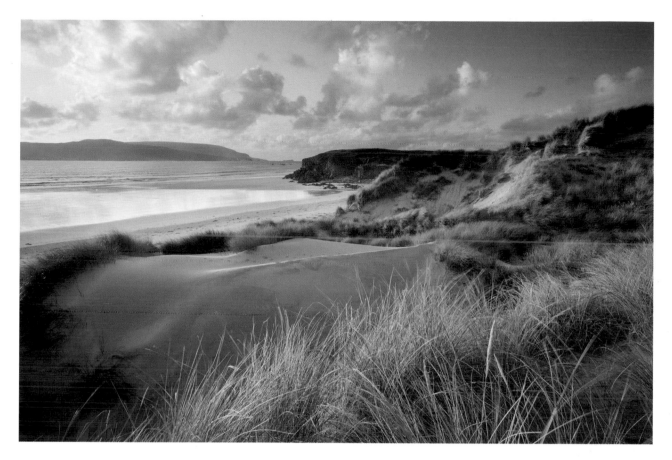

Sand dunes at Faraid Head, Balnakeil Bay, Sutherland
October

Soft dunes advance slowly along the coastline, forming huge waves. Although individual sand grains are solid, together they behave almost like liquid. Wind and water both have a powerful effect on this landscape, the breeze perceptibly shifting the dunes as I watched. The sand is always renewing itself, smoothing over the previous day's footprints; perhaps it is this restlessness that makes the environment so interesting.

Late-afternoon side-lighting is ideal for picking out crests and hollows in the dunes. This image is taken from a viewing position where areas of light and shadow appear layered one over the other, the tonal contrast providing the illusion of depth. Textural grasses form a strong feature at the front of the frame, inviting the viewer to look through and beyond them into the rest of the scene. Framed against a backdrop of darker sand, the dune grasses' presence is heightened. Conversely, the furthest part of the landscape is also the darkest, so this area recedes naturally. Flattering light interacting with striking contours produces a three-dimensional result.

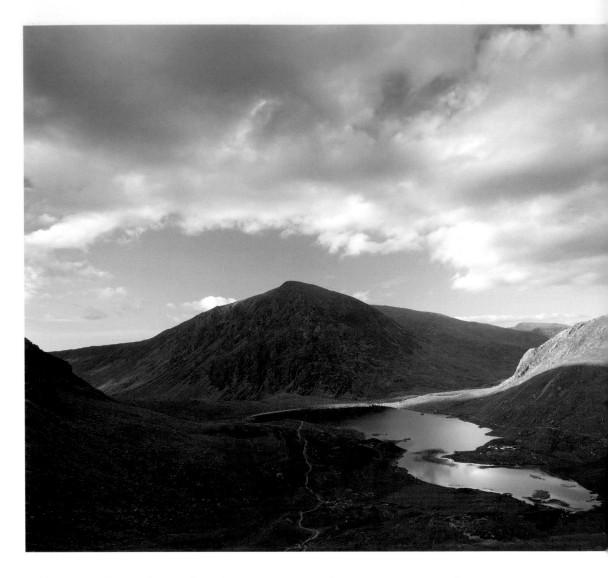

Llyn Idwal, Glyderau and Pen yr Ole Wen, Gwynedd
June

A line of light follows the upper reaches of part of the Glyderau range, converging on a single point at the base of the further peak: Pen yr Ole Wen. This is a powerful tool for directing the eye into the distance. A sense of diminishing scale is created by the proximity of near mountains and the comparatively small size of the further peak. Photographing from an elevated position provides a valuable overview of the terrain, allowing the relationship between contours to be appreciated.

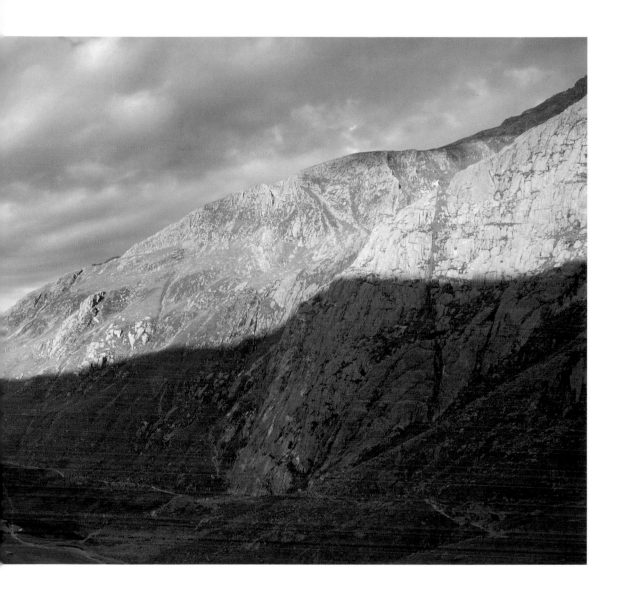

The extensive cast shadow is a result of the neighbouring peak, its monumental size preventing direct light from reaching the valley bottom. It is invaluable to know the height of large landmasses in relation to the sun's position at any given time of day or year, as this will determine where shadows fall. If it is desirable for a certain feature to be illuminated, direction and angle of sunlight are everything. Failure to take this into account could result in areas remaining stubbornly in shadow. Fortunately, in this case, the deep valley is not all dark as Llyn Idwal's calm surface reflects the sky's luminous blue.

Texture

The relationship existing between different textures is as important as that which occurs between variable colours, tones, shapes and so on. Contrasting textures are less immediately obvious than the pairing of complementary colours, but they are still fundamental to the appearance of a photograph. For example, smooth flowing water next to hard rock encompasses two very different textures. As a sole subject moving water is likely to be vague and possibly uninteresting, however in combination with solid stone, the juxtaposition works exceptionally well as the opposites define each other.

Using textures effectively gives photographs a tactile quality, as though you could reach out and touch the subject, bringing the landscape to life. It can take a moment to step back from what is in front of you and describe the scene's textural qualities, especially if other strong impressions, such as vivid colours, dominate. It should be stressed that to get the best out of environmental textures, lighting conditions must be favourable.

Portwrinkle, lone rock, Cornwall
July

In overcast lighting conditions, this small detail on the shoreline made a good subject. It is a simple photograph consisting of only three parts, each component justifying its inclusion by having a strong textural quality. Soft waves engulf rough rock as they break on the shore, the white foam smothering crisp sand grains with a fluid motion. The boulder against a background of just sand would not be nearly so interesting as the prospect of framing it against water. Sand and rock, made from the same material have similar textures and water is the vital factor that separates these elements visually.

Once I had spotted the rock among all the others littering the beach, picking it out because of its pointed shape, the biggest challenge was to capture the wave in the right place. I had an idea that the wave should fan towards the front of the frame, spilling across the beach in a pleasing shape. This was a case of trial and error, watching the swell and reacting quickly. Sometimes when the end result works, it is often as much a case of luck as it is of skill.

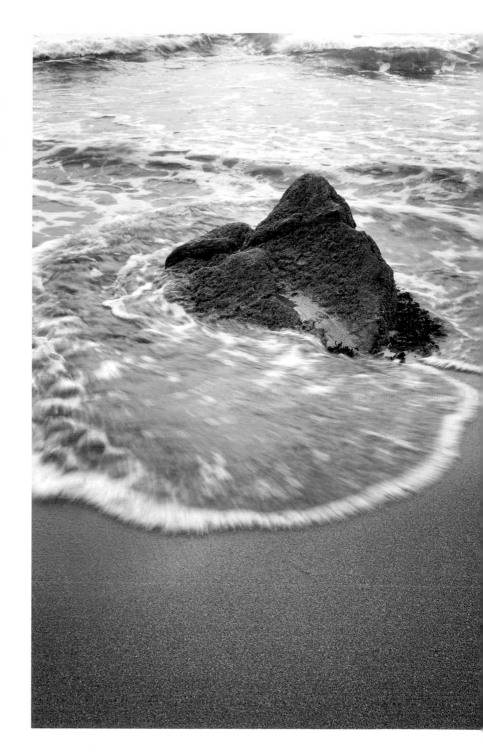

Derelict field barn, Woods Moss, Cheshire
March

Seen from a distance snow-fields tend to appear as fairly flat areas of white blankness, but from closer to it is a different story. As is so often the case with low-relief textures, they can be perceived only when viewed from near by. A low camera position ensures that the lens is merely inches away from the snow's surface, and it is this immediacy that makes it possible to see the individual powdery particles.

The right kind of lighting is key, the low sun of a spring afternoon casting longer shadows, which create contrast with bright reflective snow. Sunlight arriving from overhead would obliterate shadow definition, once again making the snow appear flat. Although the snow's texture is significant, there is still a risk of it becoming bland. For this reason small intrusions of grass are included to break up the uniformity of the space. The hard stone barn's angular lines stand as an isolated focal point among snow-smothered fields.

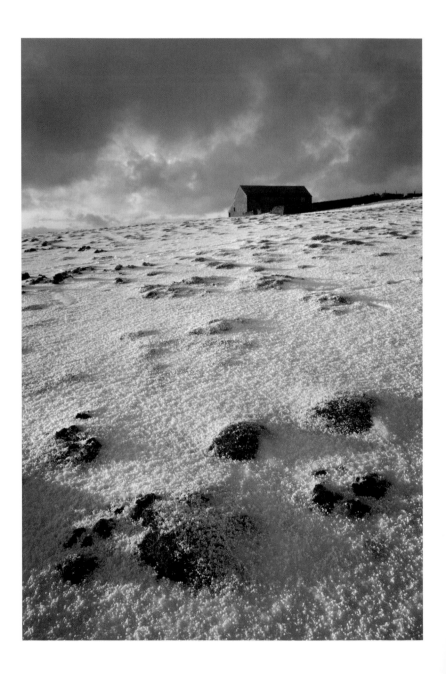

Thwaite Scar, limestone pavement, North Yorkshire
March

The erosion processes that are responsible for forming limestone pavements have created environments cut with deep scars and strange surfaces that come to life around sunrise and sunset, when raking light accentuates subtle details all but invisible at other times of day. Viewed closely, the uneven lichen-encrusted rock is transformed into a lunar surface complete with crater-like pockmarks and dark chasms branching off in all directions.

The richly patterned rock is alone interesting but the effect is greater when seen in relation to the sparsely distributed grasses that inhabit some crevices, whose lushness brings life to this desolate place. By combining these complementary parts, the solid stone seems all the more rigid next to the windblown softness of grass blades. Each emphasises the other's texture and between them they appeal to both touch and sight.

Composition

Composition, expressed simply, is the art of arranging relationships between subjects within a specific space. Put like this it sounds uncomplicated. However, because the photographer is documenting the real world there are many factors that pose challenges. Sometimes there are obstacles that are best excluded but the problem is present from any position because a suitable vantage point cannot be found. Often the challenge is not being able to get close enough to the subject but on other occasions it is a case of not being able to get far enough away. Carrying a variety of different focal-length lenses helps but they cannot deal with every situation. However, problems need solutions and this is countered by carefully considered composition.

Compositional styling is partly dictated by fashion, as we do not create art in a vacuum. Consciously or not, we borrow ideas from all around us. Thankfully we are all different – two photographers pointing their camera at the same subject will produce different images. Their arrangements of the subject are as individual as their signatures, unless they deliberately choose to emulate the style of another. Composition is a deeply personal choice as it is where the concepts and feelings motivating the individual photographer are expressed.

When arranging a photograph I start by asking myself what feelings the landscape inspires. For example, open moorland might be sparse, save for a single tree, so how do you relate to this lone organism and the great space surrounding it? If the scene is mountainous, is the impression one of awe or foreboding? Perhaps it is a blend of the two. This questioning is an attempt to engage with the spirit of place, and to photograph a landscape that looks and feels like the epitome of itself. If emotional impressions inform the photographer, it is possible that their sensations will be transferred to the final image. The thoughtful photographer can pinpoint and exploit the elements that provoke the strongest reaction.

The topics included in this section are the backbone of my approach to composition. I explore the processes that go on inside my head, steps repeated so often that they are now implicit.

Sometimes it is as if the composition arranges itself, almost without my input, as if the photograph were the result of a meditative state. However, when the subject is difficult, I once again become conscious of the guiding principles whirring away in my brain. The more challenging the situation, the greater time spent methodically relating the intended photograph against this checklist.

Elements

Elements are the building blocks of an image, the right combination forming a coherent impression of a landscape. The art is deciding on which descriptive elements to use: knowing what is essential to the photograph's story, what can be compromised and what is best left out. An important criterion is not to make a composition too complicated. Including a large amount of detail, such as many colours or too many different subjects, results in chaos. Adopting the less-is-more approach that has defined modern visual aesthetics can prove worthwhile. An image may work with one element alone but this would have to be a strong subject to warrant such attention. As soon as two or more elements are involved, a dialogue begins between them. To clarify this process I have been known to count up the main elements within the scene. If the total starts to climb above a handful, it may be necessary to rearrange the image to make it more concise.

The other important issue is where to end the composition, where to crop? When thinking about this, ask whether the whole item or only part of it should be included, and if only part of it will fit, is a fraction of the whole enough or is it better to exclude it all together? If only a tiny proportion of an object is visible, it can appear meaningless – as though it were included by accident. Too many areas like this and the image's intended meaning will be undermined. An element that is weighted towards the frame's edges, with no space around it, may feel crammed in. Whereas seeing the entire subject – or as much as is necessary to make it recognisable – within an appropriate space, leads to clear and balanced compositions.

Taigh Bhuirgh – golden light, Isle of Harris
September

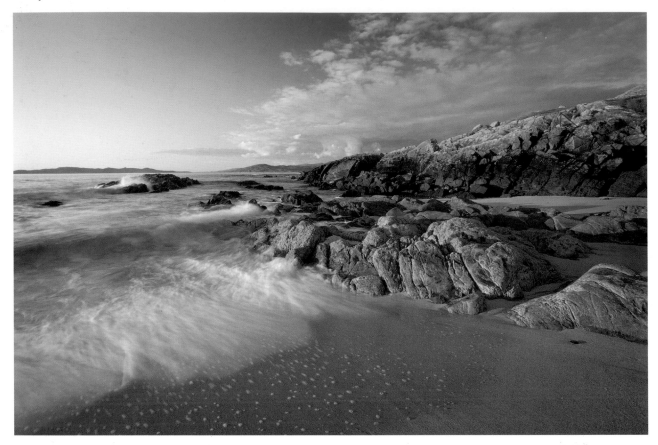

The west coast of Harris is known for sandy beaches framed by jagged rocks and washed with clear blue Atlantic waters, all perfect material for landscape photography. Taking heed of simplicity, this composition consists of these three elements and just one other, the sky. When there are fewer items in the frame, whatever is included will feature more strongly. Ask yourself how many components can be excluded from the equation before the image ceases to mean anything.

First, it was the triangular rocks caught in vivid light and pointing arrow-like into the sea, which caught my eye. This was quickly followed by the wave rushing back and forth, cutting diagonally across the frame as it did so. Fortunately, the clouds appeared to continue along the line suggested by the wave, creating a continuous flow from bottom left to top right and back again. Next to consider was the sandy beach, where the wave was given greater priority because it is a more dynamic part than the flat sand it covers.

Ramsley Moor, silver birch, Derbyshire
February

A close crop on this silver birch reveals enough information to show that it is a tree, but it did not seem necessary to include the trunk. It was a comparatively heavy black line counteracting the delicacy of the thin branches, so it had no place in this idea. The result is such that the branches appear to hang in space, giving the image an ethereal quality.

This composition is stripped down to just three elements: a misty dawn sky, the sun and the tree silhouette. It needs nothing else. The viewpoint allows the tree to frame but not fill the space around the sun. After waiting a few minutes for the sun to rise a little further, it then sat in the transition between grey cloud and pink sky.

The simplicity of Oriental aesthetics, specifically tree blossom paintings, influenced the arrangement of the elements within this scene. Skeletal winter trees are approaching abstraction in a way that branches laden with leaves are not. The leaves, although beautiful in their own right, are simply too decorative for an image of such starkness.

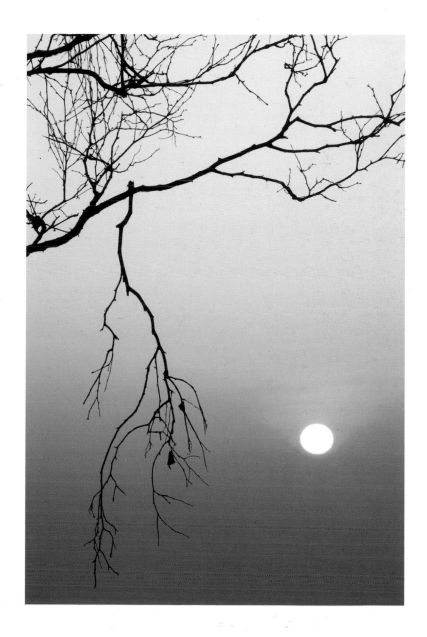

Loch Coralach mirror, Dunvegan, Isle of Skye
September

Although it had been a long and tiring day, the colours of fading dusk and the still loch were irresistible. There was something about the calm purity that made me reach for the camera. Sky and water appear almost as one, the reflection on the loch's surface a facsimile of the sky above. The silhouetted strip of land, a break in the continuous blue, forms a reference point made all the more interesting by the subtle symmetry. Submerged reeds provide detail defining the foreground, a vital point of interest that reveals scale.

Four elements: sky, water, land and reeds, although existing separately, are united by the wash of colour. Space is important to create a calm and ordered composition, each element requiring its own distinct zone without too much interference from an adjacent subject. Like islands, these elements appear to float independently in a sea of blue.

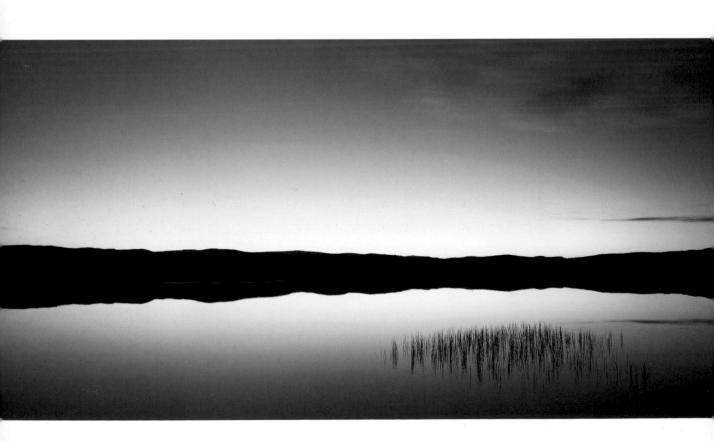

Positive and Negative Space

Each and every element featured in an image needs to be comfortable within its own space, as though things need room to 'breathe'. Without this sense of space an image can become cluttered, cramped and even claustrophobic, which is particularly relevant at the frame's edges. If there is too much going on at the periphery, it will distract attention away from the frame's inner zone in which the main subject is likely to be placed. Conversely, if there is too much space, it becomes a void and the image risks becoming vague. The 'negative' space and the 'positive' subject are equally important. Like all things, a balance between these two extremes is desirable.

The theme is easily applied to landscape, solid terrain being positive whereas the sky above is negative space. These opposites define the shape of each other. When photographing a vista, the land may well be the first consideration but the sky is just as relevant. Blank skies can be an overwhelming negative space threatening to undermine an otherwise well-composed photograph. If sky is of uniform appearance, it is better kept to a minimum, as it is not an interesting enough element to feature. In the case of an overcast sky, the contrast problems associated with this type of 'white out' mean that it is better excluded altogether. To take such an image would be pointless, as one would be photographing an empty area, which is inherently without detail.

Perranporth arch, Cornwall
June

This perpendicular arch is a natural negative space, carved into the rock by the sea's unrelenting force. A hole is an obvious example of negative space; it is an absence, its shape revealed by the positive elements surrounding it. In this photograph the effect is magnified by the appearance of peering from a shaded area into bright sunshine beyond.

In order to achieve maximum impact within the composition, it was necessary to ensure that the sky appeared only in the archway. If the sky also appeared above the cliff at the top of the frame it would distract away from the arch-shaped hole. A close crop in camera has prevented this problem. As an added bonus, the near perfect reflection on the pool's surface provides a splash of illumination in the frame's lower portion. Elevating the presence of this shaded area by extending the tonal range, enhances depth.

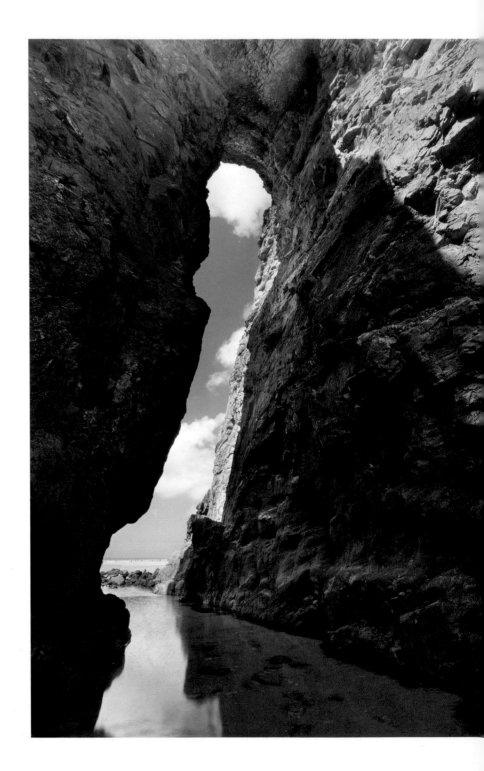

Bogbean, The Fairy Glen, Isle of Skye
September

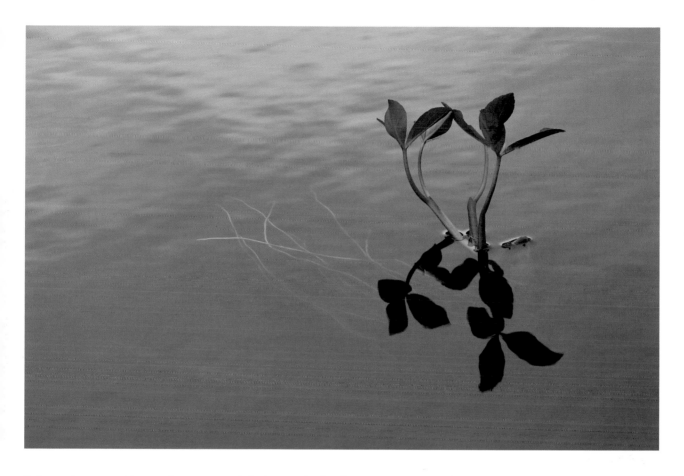

When photographing a plant or tree it helps to think of it as a portrait. In the arrangement of this image, a concept usually associated with portraiture has been applied, which is variously referred to as 'lead room' or 'edge attraction'. The theory states that when photographing a person, their body or line of sight should lead into the largest not the smallest space in the frame. This placement suggests they have an area to 'move' into, which is greater than that behind them, allowing them the freedom to walk forward without encountering a psychological obstacle or the edge of the frame.

Here the plant needed to be placed to the right because the submerged roots lead left into the frame. If the plant were on the left, the roots would breach with the edge of the frame and appear cropped, creating an entirely different feel to the composition. The water is a blank 'foil' creating a negative, but not empty, space all around the subject. In addition, like most plants and trees, the bogbean's shape is asymmetrical. Because it has a slight weighting towards the left, this position subtly reinforces a lead into the greatest space.

Castleton fields, mist and frost, Derbyshire
December

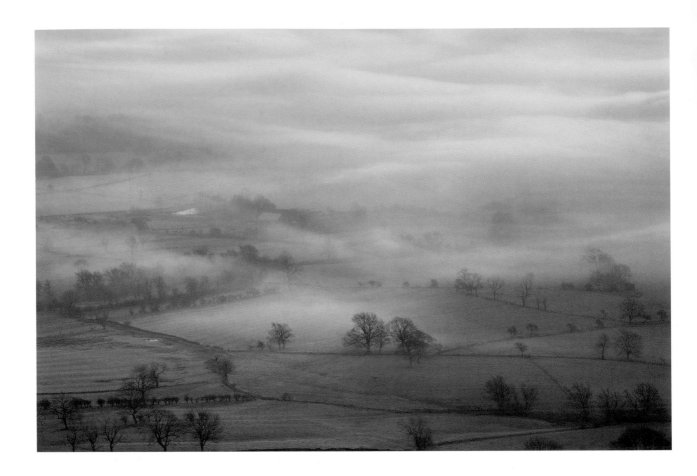

There is a stark contrast between the main components of this image. A sense of emptiness is evoked by mist enveloping the landscape next to the comparative solidity of the tree outlines and field walls. Misty scenes are indistinct as spatial references are reduced, so mist alone is unlikely to make a great photograph. However, when combined with a strong positive element, a satisfying balance between the two extremes can be realised. This attempt to create equilibrium between presence and absence informs all my photographs.

The hardest part of arranging this composition was defining the right area of the landscape, while the mist shifted and rolled unpredictably across the fields. The idea was to include just enough of the more shapely trees to provide structure but not so many that the image became cluttered, as there was a danger of one skeletal outline competing with another. The trees and walls are there to contain the mist but tension exists where its random motion threatens to engulf all in a glowing pink cloud.

Relative Height

We all see the world from slightly different heights but the range between us is not that great. In order to get the best view of a subject it might be necessary to climb a hill or even to lie flat on the ground. A scene photographed from the wrong height can cause problems such as an apparent lack of space between objects so that they appear to collide with one another. At the other end of the scale, if there is too much space between objects they appear disconnected from each other.

It helps to bear the extremes in mind. A scene viewed directly from above gives a plan view as in aerial photographs. You see no vertical height, only the horizontal relationships between subjects. Alternatively, lying flat on the ground and looking along it, you would see the vertical height of an object but not perceive the horizontal spacing. Any large objects nearby will obscure what is situated behind them. Both these opposites result in a flat representation of the world, the very factor that the photographer spends so much time trying to avoid. This can be especially problematic when relating foreground to midground and background. When considering where the lines of these zones are drawn, it is important to create visual separation between near and far objects.

The way to judge the best viewing height for the subject is to move around it, trying a slightly higher vantage point then crouching down low and noting the difference. Move towards the subject and then away, assessing how proximity affects the space between objects. This should counter the natural tendency to take photographs from eye-height, not that this is wrong. It is simply the most obvious viewing height and it is always worth exploring the immediate environment to make spatial relationships between elements as dynamic as possible.

Glen Affric, pines and setting sun, Highland
September

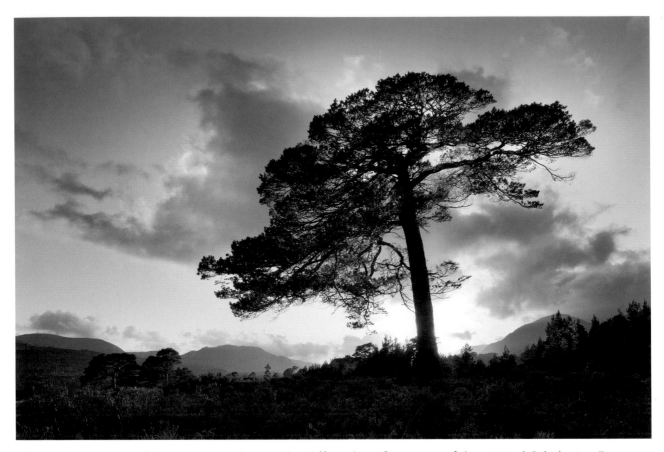

This pine tree is one of the giants populating Glen Affric where fragments of the original Caledonian Forest can still be found. Its sheer size marks it out from the other trees and, combined with its solitary position and clear views to distant peaks, I knew it would make a good subject. However, when initially surveyed from eye-height there was a small problem in that the pine's lower branches merged with the vegetation behind it, making the all-important separation between foreground and background unclear. In order to create a definite outline against bright sky, the pine needed to be viewed from the correct angle.

To maximise the gap between tree and land, the camera was positioned as low as possible. This is where an adaptable tripod was useful, enabling my camera to be almost flat against the ground. All the effort paid off as the gap was just about big enough, the lowest branch clearing the land with a small amount of room to spare. This brought about other advantages; for instance, more of the tree trunk could be seen contrasted against the bright sky and provided a better view of the low-growing moorland vegetation. The heather that made up the large majority of the ground cover would be less apparent if photographed from a higher viewpoint.

Roseberry Common, three trees, North Yorkshire
May

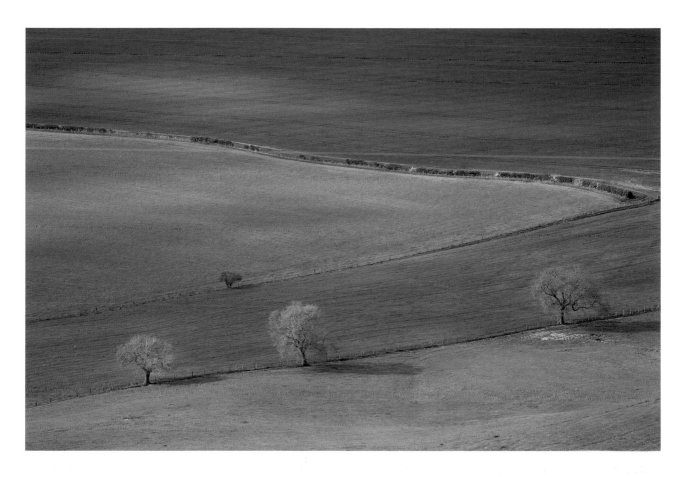

Hills offer great vantage points from which to survey the world below. Roseberry Topping is one that offers views in all directions, being one of the higher landforms in that particular locality. From the top, man-made patterns could be seen stretching across the farmed landscape, fields divided by low fences and hedgerows. The pattern formed by diagonal lines, different green hues and the three vertical trees growing along a field edge, made a simple but effective image.

From my lofty position, the linear hedgerows and fencing appeared spaced at convenient intervals. If the viewpoint were any higher, further space would start to appear between these elements and their relationship would become less significant. Conversely, from a point only a little further down the hill the trees would begin to overlap the field edge behind them, leading to a reduction in the spacing and resulting in a less coherent photograph.

Snowdrop, Chatsworth Estate, Derbyshire
April

The diminutive snowdrop only grows to a few centimetres tall and to see any level of detail the camera needs to be down at its level. If the image were taken from a higher position then it would create a distorted impression, as the upper flower parts would be closer to the lens, partly obscuring the lower parts, and the more of an angle the subject is viewed from the greater the effect. Here, the camera is arranged parallel to the flower, ensuring that there is minimal distortion.

Controlling depth of field (DOF), or the area of apparent sharpness within a photograph, is another reason for being at the correct height in relation to the subject. If the camera's plane of focus is parallel to the flower then DOF will be consistent across it. As this image was taken with a 100mm macro lens, to enlarge the flower to fill the frame, from a distance of around 15cm, and set at an aperture of f/2.8 to throw the background out-of-focus, the DOF is measured in just millimetres. This makes it all the more important to have the camera exactly parallel to deliver maximum sharpness where it is required.

Distance and Scale

When moving around a point in space, your relationship with close objects changes more noticeably than with those that are distant points on the horizon. To change your view of a foreground subject, you might need to move only a few centimetres; for a distant landform, you may have to travel miles. In addition to moving the camera position around the subject, different focal length lenses are used to transform the scale and proximity of objects, while also changing the apparent perspective between them.

The focal length that best portrays the world as the eye sees it is the 50mm lens (on 35mm format). It offers a close match of perspective and scale with no obvious distortion. While this lens is perhaps ideal for portraiture, because the shapes of faces will not appear distorted, it has less use to me out in the countryside. This is a stylistic choice on my part, which will become clear in due course.

When photographing broader views, deciding which lens to use is based on a couple of simple questions. Are there elements near by that are worth including? In this case, a wide-angle lens is the best option for getting as close as possible, while still being able to contain a large proportion of the foreground subject within the frame, allowing a proximity that gives the viewer a clear idea of where the photograph was taken from. Or is the main interest a fair distance away? To make an object that appears small due to its remoteness larger, then using a long lens will magnify the significance of that subject. This also provides the option of cropping out less exciting areas of the landscape.

Different focal lengths alter perspective, or the apparent distance between objects. At the wide end of the range, perspective appears deeper and objects have more space between them, the distance appearing further away from the viewer. With a longer focal length, perspective is shallower and objects appear to have less space between them, the distance being brought nearer. Because of these powerful spatial alterations choice of lens has a massive effect on the resulting composition.

Wide

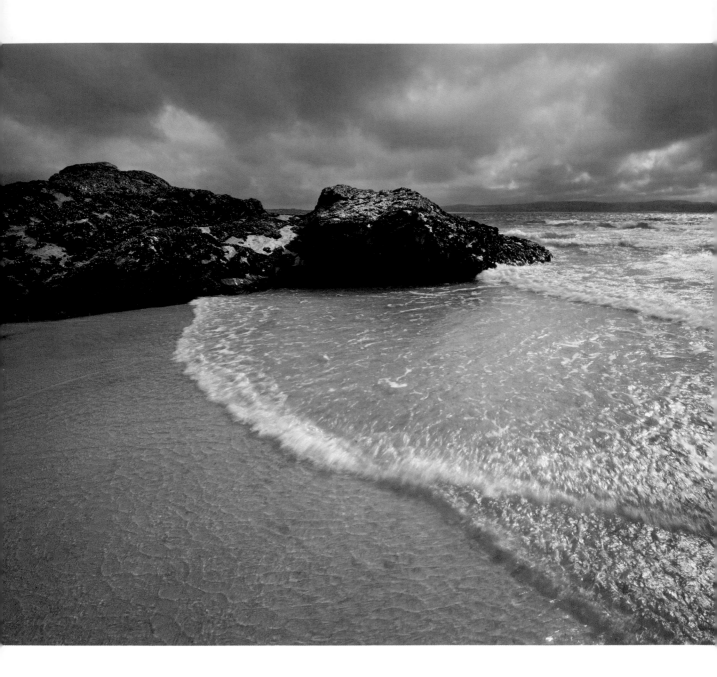

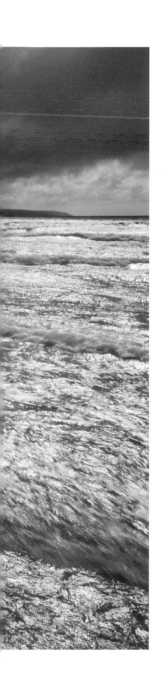

Godrevy Point, St Ives Bay, Cornwall
June

What I wanted to record in this image was the energy of the incoming wave. In order to create maximum impact, the wave would have to fill a large proportion of the frame, using the edge of the breaking wave to guide the eye into the composition. Choosing a wide focal length of 17mm has allowed me to position the camera right next to the wave, providing a degree of proximity that directly involves the viewer in the action. This closeness is exaggerated by a low viewing position, inches above the salty splash, which highlights each of the watery ripples.

Because 17mm is so wide a view a side effect of perspective distortion is beginning to show. The near rocks and the far horizon are slightly curved, which, when more pronounced, is known as the fish-eye effect. The shorter (wider) the focal length the more noticeable it becomes, ultimately rendering the world completely spherical. In this case, the curvature is slight. However, if there were any straight vertical lines near the edge of the frame they would appear curved too, possibly undermining the image. However, as much as it can be a problem, this distortion can also be used for creative effect.

Callow Bank, North Lees Estate, Derbyshire
January

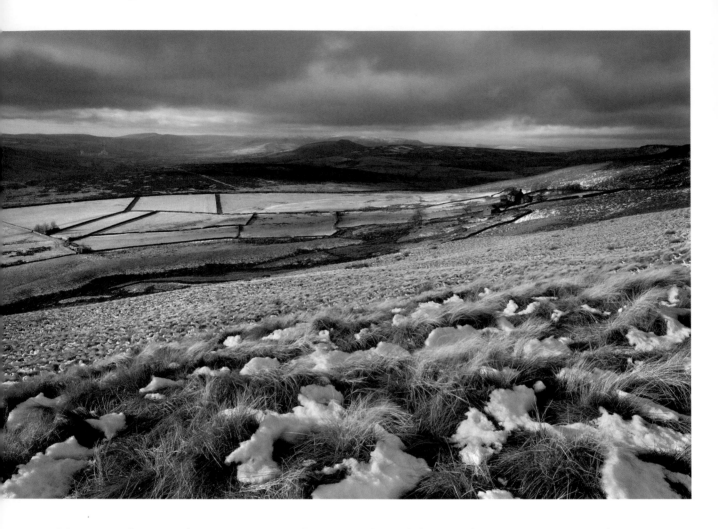

This image illustrates the consequences of using a wide-angle lens, in this instance 30mm. A close foreground subject has been arranged to fill the lower part of the frame, allowing patterns in the grass and snow to come to the fore. The space between this area and the fields in the middle distance is greatly exaggerated, helping to separate the image into distinct zones. The broadened perspective offered by this focal length felt like an appropriate response to the expansive moorland landscape.

The outcome is that the farmstead in the middle distance appears very small, but this was a reasonable compromise as it is a less important element and not the photograph's main subject. Also the seemingly tiny mountains become less significant. Again this is acceptable as they are not the image's main point. The peaks simply form a suitable background that works in context with the whole photograph.

At the edge of Torridon Forest, Torridon, Highland
September

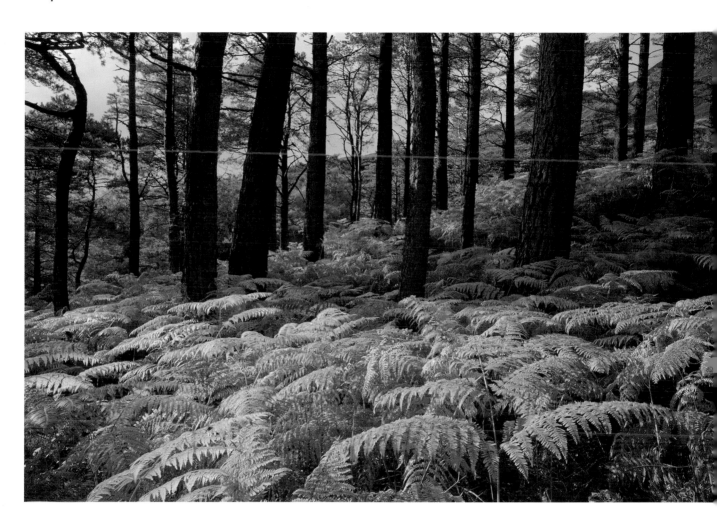

For this shot taken in a somewhat confined environment, a 23mm focal length was a good choice as it was neither too wide nor too long. To go to a much wider focal length risked creating too much space between elements, the trees becoming distant and isolated, and losing their relationship to brackens in the foreground. A longer focal length would have reduced the space between elements and the resulting image would have appeared much flatter.

At this focal length there is enough room between bracken and trees to feel comfortable. The trunks exhibit noticeable diminishing scale, heightening spatial depth: those nearest the lens are bold texture-rich shapes while the further ones are mere suggestions. The sense of space created by this reasonably wide focal length is aided by choosing a camera position that showed the natural separations existing between tree trunks. If this fact were not taken into account, then the woodland would appear as a jumble of chaotic lines with no appreciable gaps.

Long

Dunstanburgh Castle, misty dawn, Northumberland
September

The ruined castle's evocative form was intended to be the image's main point of interest and yet I wanted it placed within the lonely surroundings of the deserted beach complete with encroaching mist. From my vantage point a slight magnification was required to make both boulders and castle appear larger. A 70mm focal length created the desired effect and it also provided a tight crop ensuring that neither bright sky nor dark beach came to dominate the image. The moderately compressed perspective seen at 70mm is helpful as it reduces the apparent distance from foreground to background, making the relationship between these parts more significant.

The boulders in the foreground are several metres distant from the camera and this is significant as, owing to the relatively narrow range of DOF associated with longer focal lengths, it would be impossible to expect both the ground at my feet and the far-away ruin to both appear sharp. This factor determined where my lens was aimed and how far away the camera was located from the near object. If anything closer needed to be sharp also, either the camera would have to be moved further back or a wider lens be used, both of which would have altered the composition

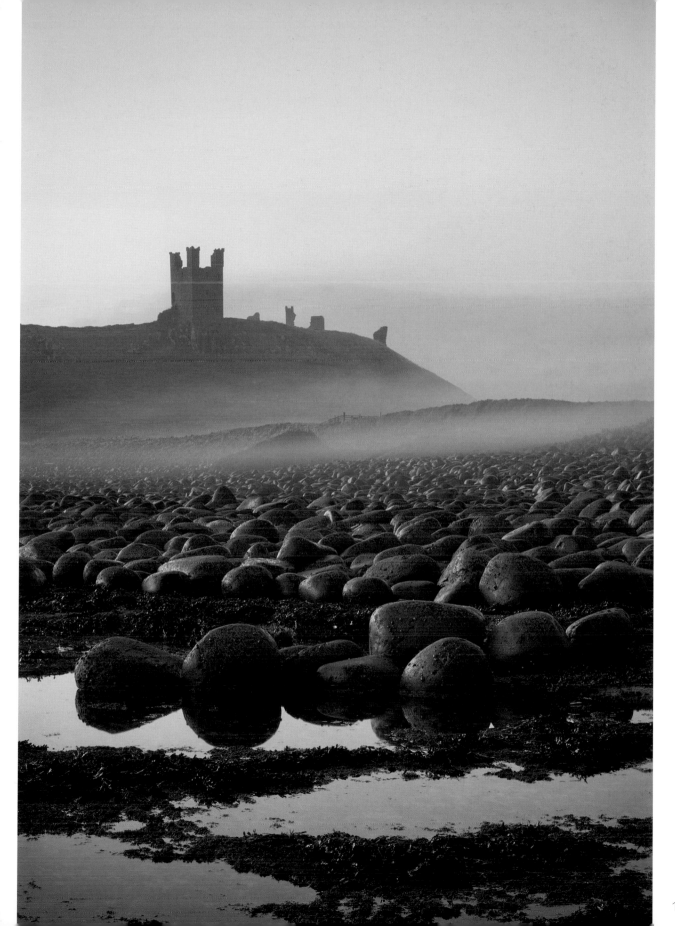

Kinder Scout and Bleaklow from Derwent Edge, Derbyshire
August

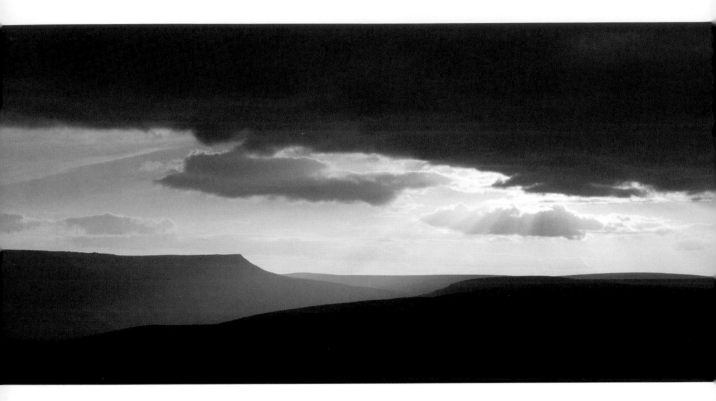

With the setting sun casting the back-lit landscape into shadow, I became attracted to the silhouetted landforms of the distant horizon and the shapely clouds above, which appeared to hug the landscape's contours. The only descriptive shapes of interest were the mountain plateau's steep escarpments on the horizon, so there was little point including too much of the dark mass below. Just a strip was sufficient, acting like an anchor point. Deciding where to crop at the bottom of the frame was dictated by the area of back-lighting filling in the valley to the far left, creating a layered effect that was well worth featuring. A 113mm focal length magnified the distant mountain plateau, allowing me to crop in close enough to exclude much of the shadowy landscape.

Although giving priority to the sky, judicious cropping of this area was still very necessary. Too much of the brooding cloud risked making the image top heavy, which is why a zoom lens is so helpful. Zooming in and out eventually achieved the right balance between sky and land. Lenses of a fixed focal length, although of undeniable optical quality, are less flexible out in the field.

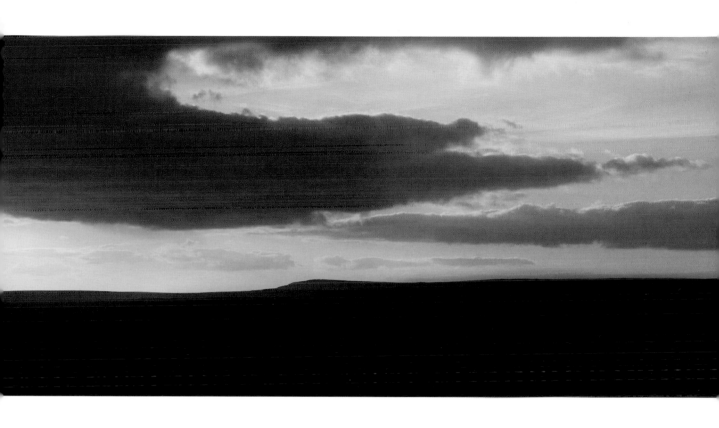

Calcareous grassland, Chee Dale, Derbyshire
May

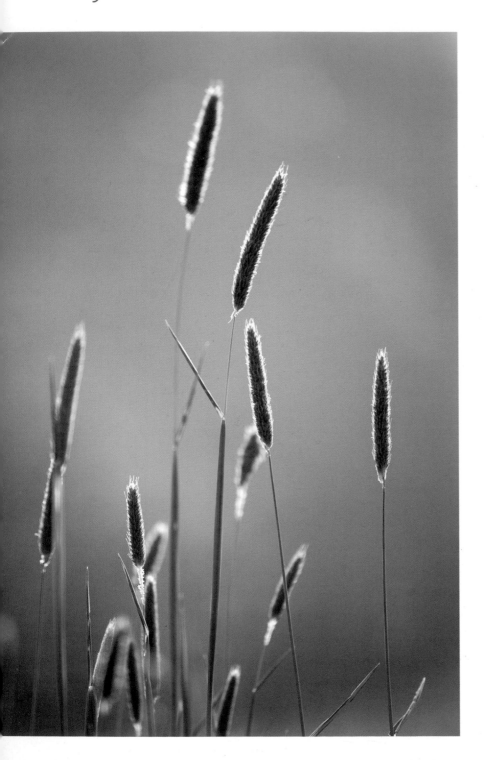

Long lenses are used not just for enlarging distant subjects; they are also excellent for working with closer small-scale elements. This image of haloed, back-lit grasses was photographed at a 200mm focal length from a distance of just over a metre away. The reason for choosing a long lens in this case is because of the way focal length impacts on DOF. The longer the lens the shallower the DOF, whereas the wide-angle lens is much broader by comparison.

When photographing botanical details, creating a blurred background that does not detract from the main feature is desirable. It then follows that this shot is best taken with a longer lens, as the out-of-focus area is easily achieved. The 200mm focal length combined with a large aperture (f/4) has recorded an exceptionally narrow zone of sharpness and only a few grass stalks are recorded with absolute clarity.

Thirds and the Golden Ratio

The 'rule of thirds' is perhaps the most widely known principle of composition. What photographers refer to as thirds is derived from the proportions of the golden ratio – 1:1.618. The system built around this number has been widely used as a creative aide by artists and architects since the Renaissance. This number is seen in many different contexts throughout nature, notably in the spiral of a nautilus shell. The ratio defines the proportions of the golden rectangle, which in turn leads to the golden spiral. It is often suggested that we have a preference for subjects that exhibit the golden ratio, for example, the 'perfect' face is considered to be the one that closest matches these proportions.

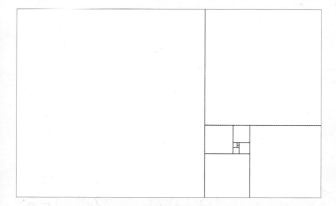

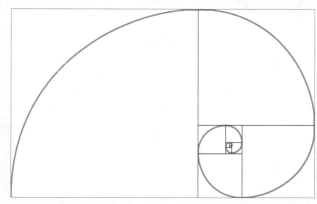

Figure 1: The golden rectangle. The ratio of the longest to shortest side is 1:1.618. When a square is drawn inside the rectangle, the excluded area is also a golden rectangle. This process can be repeated endlessly.

Figure 2: The golden rectangle featuring the golden spiral. A curving line is drawn through the opposite corners of each square. The point at which the spiral terminates is the most strategic placement for the photograph's main subject.

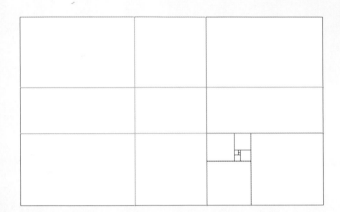

Figure 3: The golden rectangle depicting third divisions. These 'third' lines follow the golden rectangle ratio and do not divide the frame equally.

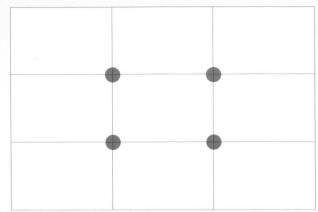

Figure 4: The simplified version of thirds used by photographers. Camera viewfinders are not a golden rectangle; instead they are commonly a 3:2 ratio. In this variation, the frame is divided into easy to visualise equal parts. The most significant points to locate the subject are where the lines cross over.

Rather than simply sticking to the 'dots' (as in Figure 4), aligning a form either vertically or horizontally along the grid works just as well. The key concept derived from the thirds theory is avoiding the edges and the centre of the frame, the centre being the most obvious and often least interesting point to place anything. Most subjects appear better offset but there are always exceptions to this rule. Use thirds as a guiding principle but do not feel bound to stick to it at all times. Creating a harmonious composition is the main concern and the final result may have little to do with thirds. However, engaging with the theory has helped to develop my personal awareness of space and how to use it.

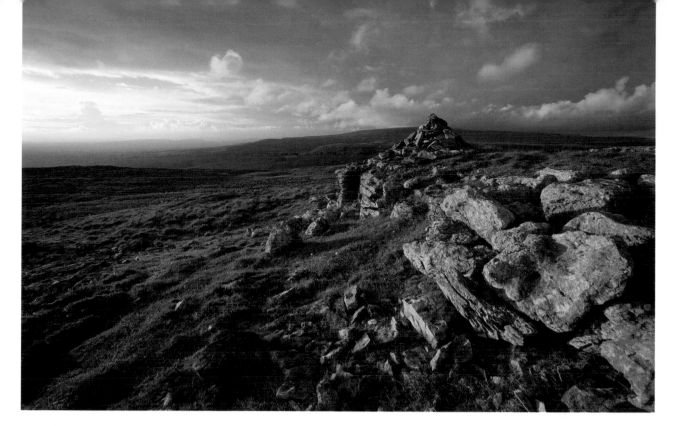

White Scars, cairn, looking down to Ingleton, North Yorkshire
October

This image's main subject is the cairn so it was important to place it in the best position. Because the landscape sloped down to the left, the best position was the top right hand point; the cairn's tip is exactly on the third. This arrangement allows the soft shadow lines created by the near rocks to lead in from the bottom right hand corner.

The cairn appears above the horizon, achieving maximum contrast by placing the point in front of the bright sky rather that having it merge into the background hills, which are tonally quite similar. In an effort to separate foreground and background subjects, it was important to make sure that the tip did not end up level with the horizon, which would have flattened the space between the two elements.

It is a classical convention to frame a landscape with the proportions of one-third sky to two-thirds land. This makes sense when relating back to positive and negative space, the solid land being given greater preference. However, if the sky were the interesting part, then it would be preferable to include more of it and only one-third land. In this particular case it was tempting to feature more sky, as it was such a rich and dramatic element, however, it felt better prioritising the weight and substance provided by the rocky terrain.

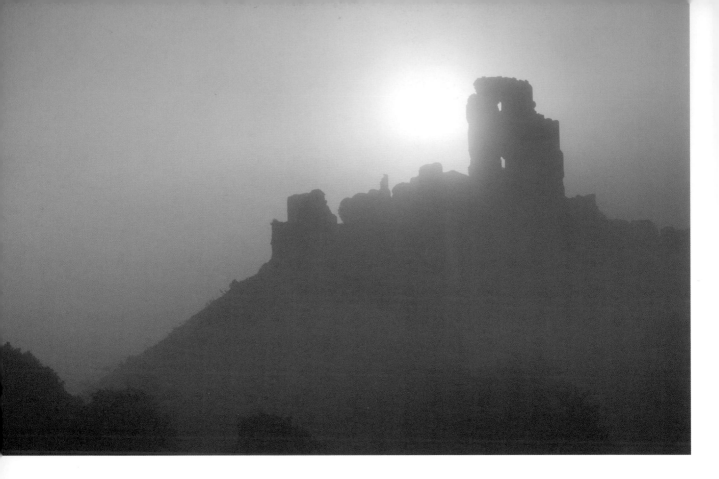

Corfe Castle, rising sun, Dorset
May

After experimenting with various compositions, some with the castle larger in the frame, others with it smaller, I settled upon the idea of making space for the surrounding woodland in order to create layers, suggesting greater depth from front to back. As the castle was the main element, it seemed appropriate to align the tower with the top right hand third. However, when so placed two side effects occurred, first the sun's bright orb came to rest in a central position and second, the best part of the trees was excluded just beyond the frames bottom left. Both these concerns were addressed by lining the sun up with the third instead, while ensuring there was still enough space to the tower's right.

It is due to compromise that the woodland remains very much on the margins rather than occupying the lower third. When the camera was tilted downwards to include a fraction more trees it reduced the space above the castle and the latter was more important. The loose way of interpreting thirds theory is at work here, as long as elements are not too much towards the centre and not too resigned to the edges then a pleasing composition can be found.

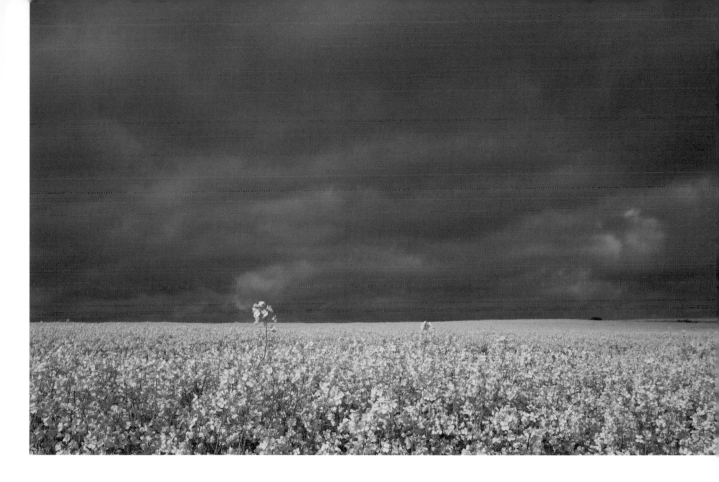

Oil seed rape fields, Whitby, North Yorkshire
May

Strong colour contrast motivated me to make this photograph and it was this that decided the final balance of flowering crop to sky. The inverse – more flowers than sky – would, in some ways, have made sense because they are the primary subject but the intense gold drowned out the muted sky, making its inclusion pointless. A satisfying compromise was reached by allowing the sky to figure as the larger element.

After wrangling with this debate briefly, knowing full well the light would be transient, I then thought about thirds. The most obvious way to follow the rule is to have one-third land to two-thirds sky, but the two horizontal bands of colour, although strong, were not exciting enough. Becoming aware of one oil-seed rape bloom taller than the rest, suddenly it became clear that this small plant was the pivotal point of the composition. With this element aligned vertically with the lower left-hand crossover point, the photograph finally fell into place.

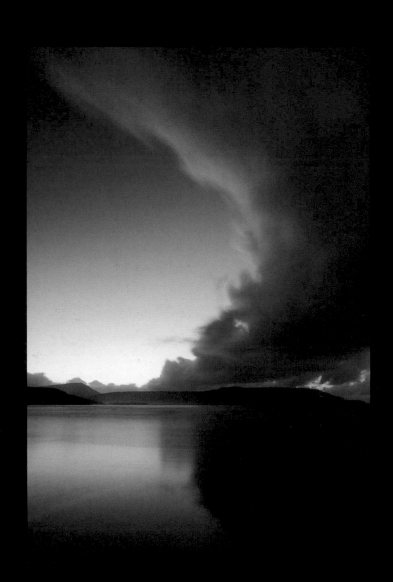

TIME

TIME

As soon as the camera has finished capturing light it depicts a time already belonging to history. Once gone that moment will never happen in the same way again. This is part of the frustration and also the appeal of photography. Light never appears the same way twice, weather systems are chaotic and the environment changes. If you have just witnessed perfection and failed to photograph it, it is a shattering disappointment. You will be left trying to recreate an experience that can never happen again. On the positive side, when something extraordinary is documented, the rewards are immeasurable.

There is a huge investment of time involved in getting to know a location. Allowing the geography and the feel of a place to get under your skin leads to an emotional connection that becomes the foundation for perceptive photographs. This does not happen on a day trip. When visiting a new location it is best to spend a good few days exploring, spotting viewpoints and watching how the angle of sunlight describes the scene at different hours of the day. As the weather can be so unreliable, there will be long periods where no photographs are taken. This time can be used productively to work out different compositional ideas and to make field notes for future reference.

When a large area of ground is being covered, even after days of tramping along paths and climbing to high vantage points, I will have only just scratched the surface, and being thorough is so important. The act of committing contours and landmarks to memory, noting every significant landform and each distinctive tree, allows me to recall

a scene inside my head offering me the chance to pre-visualise subsequent photographs, forming an important part of my method. Once this exploration is done comprehensively, on returning to a location I am primed to burst into action, light permitting.

Time is a broad concept and it impacts on photography in different ways. Being an abstract measurement, time cannot be seen directly but it is the subtext of all photographs, as they record not only a particular time and place but also an interval determined by the shutter speed. Images of the man-made environment often feature styles and objects that help to date them. However, depicting a landscape that barely changes over the years makes the scene timeless in one sense. Nevertheless, the natural environment is shaped by seasonal variation, linking the image to a specific time of year.

Photographs are historical documents, holding a special place in our affections as they assist memories of life's important moments. They are my way of illustrating the flow of natural processes at the point they become personally significant. The captured image allows me to hold on to these experiences and revisit the pleasure, and sometimes the pain, that went into making it. Intangible things such as the temperature, the sun beating on my face, cold fingers, the sense of achievement at having climbed a mountain and my aching legs afterwards, are impressions that I cannot share, but I can create an enduring record of the time and place at which all the right visual elements clicked into place.

The Passage of Time

As much as a camera captures light, it also records a time interval. These are the two ingredients that make photography possible. The way a photograph depicts time is fundamentally different from our experience of the world. We see a continuous stream of visual information, whereas it appears frozen, representing a single point in time. However, the idea that the image is a 'still' moment is not strictly accurate. A camera measures time periods in shutter speeds ranging from around 1/8000th of a second to several minutes, perhaps even hours, limited only by its mechanism or battery life. This scale encompasses all from the exceptionally fast to the surprisingly slow, placing what the camera 'sees' outside our version of events.

The strongest evidence of the camera's ability to depict time passing is the presence of motion blur in a photograph. Blur is a side-effect of using shutter speeds that are slow relative to the subject's movement, whereas a faster shutter speed is more likely to capture the scene as our brains interpret it. When shutter speeds are used creatively, they can transform appearances, which is especially effective when the camera is held steady on a tripod, meaning that any blur recorded is due to movement of the subject itself and not the camera. In this way photographs stretch and alter our perceptions, opening up a world of visual effects invisible to the naked eye.

Luskentyre, dunes, Isle of Harris
September

A soft breeze came in from straight off the Atlantic, rustling through long dune grasses on a warm late afternoon. The atmosphere was one of barely interrupted tranquillity and while the evocative sound of the wind can never be caught on camera, the fluid motion of its interaction with the landscape certainly can be. As it was the grasses only stirring, while everything else appeared static, it seemed that the difference between solid landscape and this softer element would make an interesting combination.

Using a shutter speed of 1/8 second recorded enough movement to suggest the presence of a breeze, while retaining sufficient detail to show the grasses' spiky texture. Too slow a shutter speed would have made them vague, somewhat defeating the idea of using textural grasses in the first place. When working with moving subjects it is worth experimenting with a few different shutter speeds, time permitting, as it is difficult to gauge the correct speed for the desired effect.

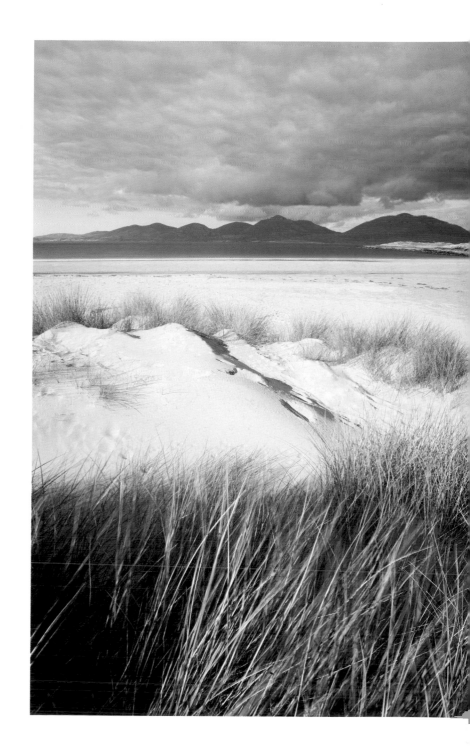

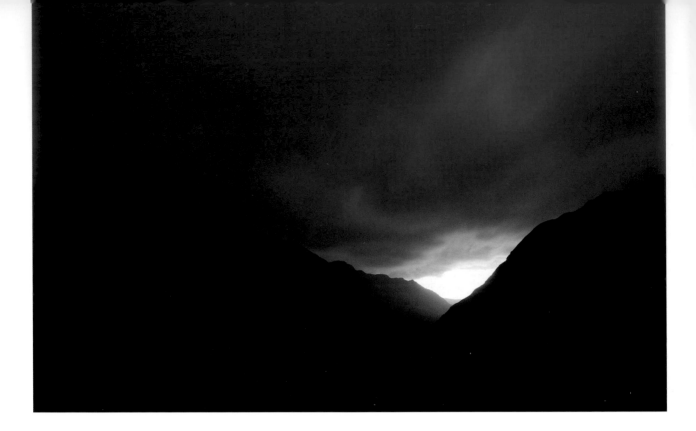

Snowdon Range and Glyder Fawr, Gwynedd
June

At the edge of night, the sun's last trace caused a pink glow to reflect from the underside of low stratus cloud. This warm-coloured light defined a point in space to which the eye was immediately attracted, much like the bright light at the end of a tunnel. There was just enough illumination to create a photograph as only a few minutes after this image was taken the dark sky and shadowy landscape merged into one, making it impossible to distinguish where one element ended and the other began.

Low-light levels required a 10-second shutter speed to achieve the correct exposure. Meanwhile air-turbulence shifted the clouds at an extraordinary rate, the open shutter recording graceful sweeping movements that indicated the current's invisible path. The cloud layer became a liquid entity, flowing in and around the mountain's dark mass, creating a slightly surreal atmosphere.

Ten seconds, although brief in the 'real world', is a long time in photographic terms. Counting away the moments while the shutter is held open makes one intensely aware of time passing. Throughout this period light and environment change, everything being in a state of flux.

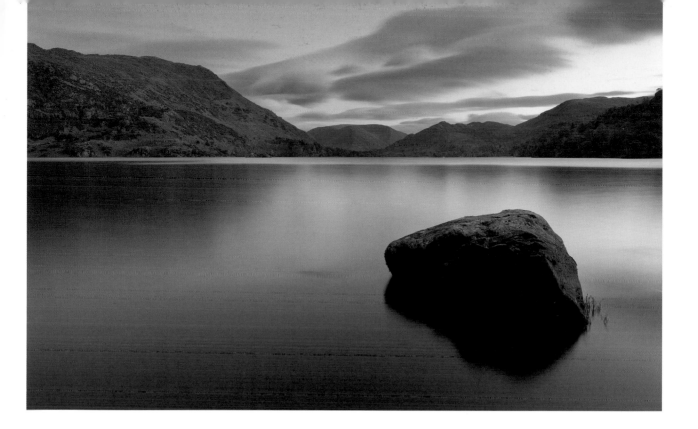

Ullswater, reflected dusk, Cumbria
November

An hour after the sun set behind adjacent mountains, the sky remained bright with scattered light. Before me stretched Ullswater's gently rippling surface, reflecting the sky like a vast uneven mirror. Naturally sparse illumination meant that the correct exposure was going to be a long one, even after taking account of light reflecting off water. After some initial estimates and a trial photograph or two, a 90-second shutter speed was chosen.

During this comparatively brief slice of time breezes came and went, creating ripples that dissolved without trace in the face of the long exposure. The time-transition recorded in this photograph created an ethereal landscape as real-world clarity is relinquished in favour of impressionism. The illusory atmosphere came from the improbable smoothness of the lake; its appearance is on the periphery of recognisable reality. Just ahead of the encroaching darkness, the camera transformed fading illumination into a lingering suggestion of rich colours and softened boundaries.

Changing Seasons

Humans generally experience time as a straight line – we are born, we live and we die – tending to see life as a series of unique and sometimes significant moments, with time, all the while, marching forward. This linear version of events is often referred to as time's arrow. Coexisting alongside this view is the idea of cyclical time, an immediate example of which is the earth's daily orbit around the sun creating night and day, as are the changing seasons. Some habitats reach their best only once a year, such as the late summer flowering of heather moorland. If the window of opportunity is brief and the moment is missed, there will be a long wait until the same time the following year. Both time of day and season rule the landscape photographer's life.

Seasonal variation is due to the earth rotating on its axis, tilted by 23.44° throughout its annual cycle. Summer is the time when our position on the earth is most directly in line with the sun. This is why we have hot summers and cold winters, or so the theory goes. However, climate change is creating seasonal anomalies such as plants blooming twice in one year, long winters and soggy summers.

Technology places distance between our lives and natural rhythms. Electric light, central heating and air-conditioning are just some of the solutions designed to overcome factors imposed by our environment. Out in the landscape, with these comforts stripped away, one is subject to nature's timetable, no matter how inconvenient this may be in practice. There is no hurrying forward through the seasons and no magic solution available to remedy the wrong kind of weather. The greatest skill in the photographer's repertoire is patience and the finely honed ability to wait while staying hopeful.

Spring Wood, new beech leaves, Derbyshire
April

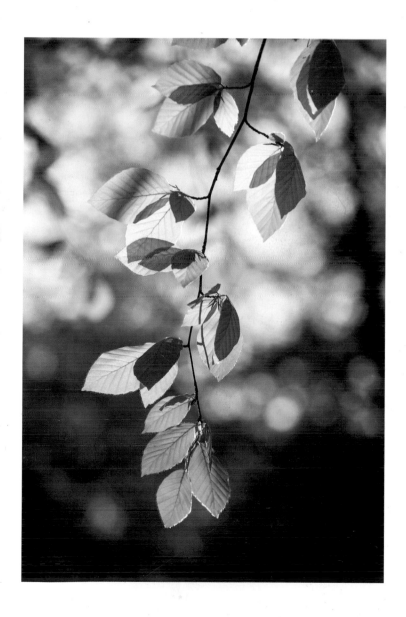

The arrival of spring colour is a huge relief after the barrenness of the winter months. Anticipation of the event builds with the sight of broadleaf tree buds swollen with the promise of fresh foliage. To my mind spring starts with the first signs of vegetation and not a moment before, despite what the calendars say. Spring is not just the collective name for three months of the year, it is also a term laden with the symbolism of renewal.

In this back-lit portrait of chlorophyll-rich beech leaves, the full intensity of the green pigmentation is revealed. High-contrast lighting transmitted through paper-thin membranes shows the network of fine structures. The leaves are radiant framed against a shaded backdrop and caught in their own pool of light. This image is a microcosm of the woodland as a whole and the world beyond bursting with rising sap and new growth. However cosy this world view appears to be, winter's touch still lingers. Early mornings are frequently frosty and, in the more northerly latitudes, the possibility of snow-fall lasts well into April.

Bedruthan Steps and pink thrift, Cornwall
May

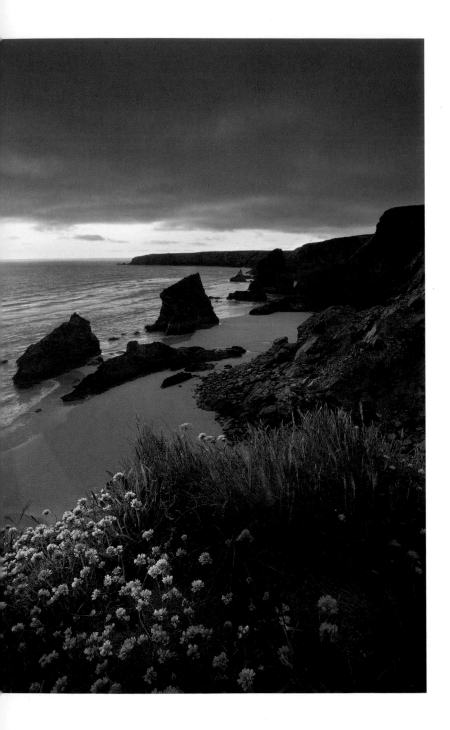

Early summer produces an explosion of flowering plants, igniting the landscape with hot colours. Magenta orchids and red campions appear in woodlands and grasslands, while pink sea thrift fringes the coastline. In the coastal habitat it is the cliff-top grassland that best illustrates seasonal influence, as far below, where the sea meets rock, is the environment least affected by seasonal variation. Only the most well-adapted plants can survive in this inhospitable salt-sprayed place and those that do are usually sparsely distributed.

Seasons advance at differing rates around the country. Here on the Cornish coast, the thrift is at its peak in the last week of May and yet elsewhere the thrift has only just begun to flower, dependent upon the local temperature. It is hard to anticipate the exact moment when plants will be at their best, the decision to visit a location at a specific time being part experience and part guesswork.

There is a downside to summer because, as the season progresses, foliage becomes a uniform green that is far from visually exciting. Bright sunshine and atmospheric haze combine to make photographing vistas problematic, not forgetting the ridiculously early sunrises and late sunsets that make the working day long and impractical.

Wasdale, old oak tree, Cumbria
October

In autumn the colours of fading broadleaf trees echo throughout the wooded landscape. This oak tree's leaves are turning a comforting barley-sugar orange, quietly hinting at the chemical processes under way. Undoubtedly, this is an old oak tree, judging by its stature and especially the trunk's circumference, but just how many seasonal cycles has it witnessed – perhaps over two hundred? Oak trees can live more than one thousand years, making them among the longest-lived organisms on the planet.

Throughout the warm summer months plant chlorophyll levels are replenished but, as the days begin to shorten, production of this chemical declines. As it is broken down, the colours of other chemicals present in the vegetation are revealed. Yellow-orange foliage is rich in carotene, which, as it is more stable than chlorophyll, persists for longer in dying foliage. The red-purple pigmentation demonstrated by certain plants is due to increasing levels of anthocyanins. Colour vibrancy depends on both temperature and available light. The best displays can be seen after dry, sunny days and clear, cold nights.

Glyder Fach from Cwm Tryfan, Conwy
February

Snow-topped mountains are irresistible subjects, as their summits seem all the more impressive after a good covering. With this in mind, I left home for Snowdonia at the first sign of falling flakes. The following morning the whole landscape was muffled by white drifts and deadened by grey sky. After two days the weather finally broke and I set out under moon and stars around ninety minutes before sunrise. This climb required plenty of time as ascending through snowdrifts in twilight, while trying to follow hidden footpaths, is tricky.

At this point directly below Glyder Fach's spiky ridge, the sharp definition of snow-covered crags against the vivid sky stopped me in my tracks. Knowing that blue sky alone would make a less interesting image, it was fortunate that within a few minutes low-level clouds began drifting into view, spreading ragged trails radiating from the summit.

Mountains shape the atmosphere that brushes up against them as air-flow is disrupted by solid rock. The way clouds appear to wrap themselves wraith-like around their summits is fascinating. Here delicately fragmented wisps roll across the gleaming ridge partially hiding it from view and casting feint shadows in their wake. The vagueness of the cloud's feathery outline next to the rigidity of angular rocks creates strong textural contrast.

Waiting: Working with Stormy Weather and Unpredictable Light

Landscape photography might have the air of a relaxed pursuit, what with all the talk of 'waiting for the light'. However, in stormy weather patience alternates with frantic activity, when quick reactions are essential to capture the all too few and brief spells of radiant light. The waiting periods provide opportunities to think about what is around you, allowing ample time to compose the photograph to satisfaction. Then it is a case of remaining poised to catch even the briefest of sunlit moments, knowing that readiness and alertness are essential for any chance of success.

Stormy weather can lead to unpredictable illumination of breathtaking intensity. In practice this means waiting for lengthy periods or walking off into the middle of nowhere underneath a brooding sky, with an unshakeable sense of optimism that sooner or later the sun will appear, when in reality often it will not. It is always testing working with the weather's whims as it affects everything so much. Willing the clouds to move away or for downpours to cease occupies a large proportion of my time.

The problem lies in the length of some of those waits, generating discord between the demands of landscape photography and time in the everyday sense. You need a lot of it in order to make good images and there are no guarantees that patience will reap rewards. Learning to cope with habitual disappointment (I write this while waiting for heavy rains to pass) is just part of the job. Choosing to ignore the fast pace of life and instead wait for hours, perhaps even days, for the perfect light is not a practical way to live one's life, but then it is done for the art, for the thrill of it, rather than for pragmatic reasons.

Glen Etive, Lochan Urr and Stob Dubh, Highland
September

I do not possess many photographs of rainbows, and for a good reason too. In spite of seeing them fairly regularly on my travels, because of their transitory nature they usually escape me. By the time all the equipment is set up they are already fading. Rainbows are among the most elusive class of weather phenomena, their temporary beauty caused by raindrops refracting and reflecting light which disperses into the full spectrum of colours. For this to happen the sun needs to be fairly low and behind the photographer, which immediately causes problems with shadows.

Being able to photograph a rainbow is a clear example of being in the right place at the right time. On this stormy afternoon the sun frequently threatened to break through the clouds and it kept getting brighter but not quite vivid enough. Heavy downpours ensued as one squall after another blew in. On the verge of walking back to my car to get dried out, the persistent part of my nature would not let me quit. By staying in the one spot, shot composed and ready to fire, a spectacular rainbow in a stunning location was recorded.

Afon Nant Peris, Llanberis Pass, Gwynedd
June

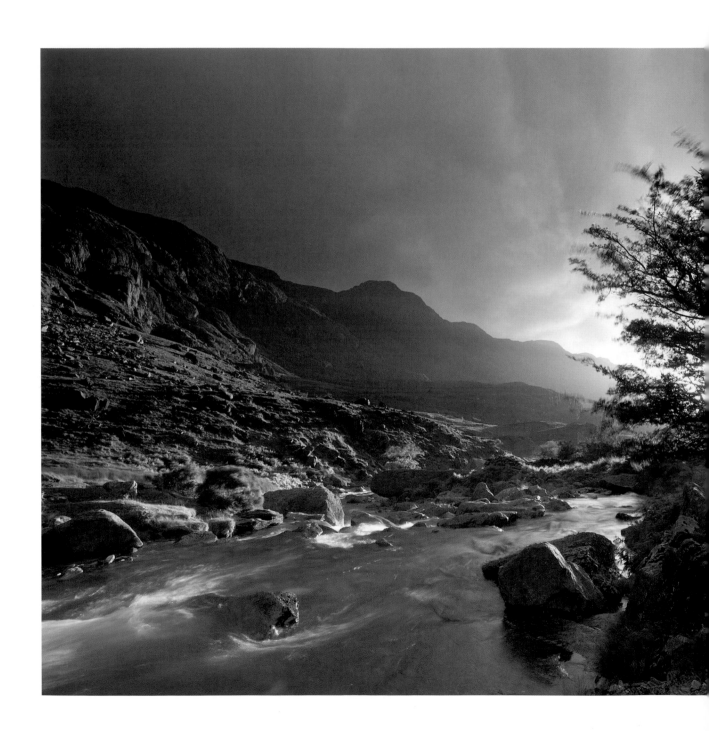

A day of wild weather finally gave way to reveal a narrow band of intense light on the horizon in the minutes before sunset, providing interesting but challenging photographic conditions. I was obliged to use shutter speeds of half a second or more in order to gain the correct exposure, extremely difficult in gale force winds threatening to blow my tripod over.

Undeterred, I found a low vantage point where I could be partly protected. Meanwhile, everything around me was being battered as the wind funnelled down the valley, the madly flailing tree and the fast-flowing river whipped in to a frenzy contrasting with the solid mountain geology.

This shot took me to the limits of my capability. Standing upright on the slippery rocks was tricky and the unrelenting wind made my eyes water, making it difficult to focus. In spite of all this, I was in my element, caught in the middle of an exhilarating storm in a landscape bathed in golden light.

Uisgnebhal Mor and Teileasbhal, Isle of Harris
October

Having intended to climb at least part way up An Cliseam, the highest of Harris's peaks, I suddenly realised that it would be a bad idea. Low cloud lurked oppressively around the foothills and so a Plan B was needed. However, an alternative became unnecessary as a sudden shaft of golden illumination spilled across the scene as abruptly as if someone had flicked a switch, turning the murky into the glorious, and reminding me how fine the line is between a grey day and stormy magnificence.

Knowing there was only a minute or two to make sense of the transformed scene, I decided to make a feature of dark clouds hovering over the bealach (gap between peaks) but the only foreground was low-growing moorland vegetation. Spotting these gneiss boulders several metres distant, they were reached after heading full-tilt through bog up to my shins. The pale grey rocks shine out amid the faded burnt orange of autumnal moorland, and they provide the scale and interest needed to complete the photograph. This fantastic illumination was a brief interlude as the cloud layer soon swallowed all trace of the sun and the world once again became bleak and cheerless.

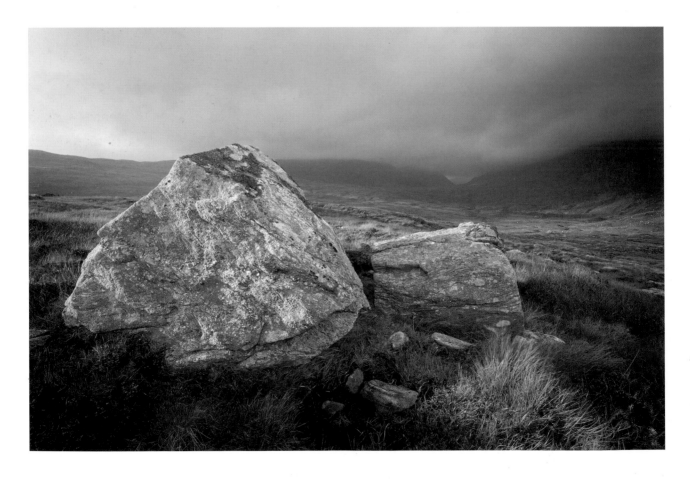

Deep Time

The oldest rocks on the planet have existed for billions of years, illustrating the difference between the earth's age, as measured in geological eras, and the brevity of human existence. The vastness stretching between then and now is referred to as deep time, a gap so broad that it defies understanding. I often think of this while waiting for the light. Because the earth's geology influences not only landforms but determines the type of habitat, a basic understanding of different rock-types is an asset to any landscape photographer.

Geological processes are yet another example of cyclical time, but we barely notice their effects because they occur over periods of incomprehensible scale. Rocks tend to be thought of as solid. However, when viewed from the standpoint of deep time, they are subject to massive change. Erosion sculpts landforms by dissolving material which is then deposited, eventually becoming new sedimentary rock over millions of years.

Meanwhile, plate tectonics ensure that continents drift and collide, deepening trenches and pushing up mountains, metamorphosing old rock into new, not forgetting the numerous active volcanoes producing yet more material. All around us time's passage causes both destruction and renewal. It is reassuring that these rocks were here an unimaginably long time before me and will be around for an improbably lengthy period afterwards.

Crumbling cliffs at Saltwick Bay, North Yorkshire
May

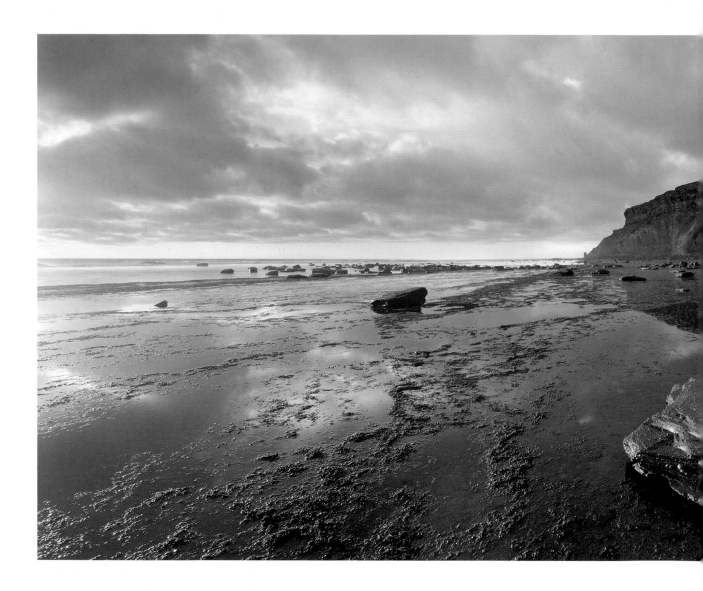

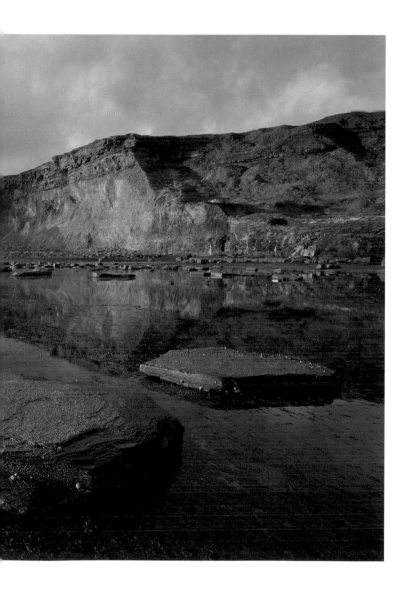

This image shows the rapidly changing coastline at Saltwick Bay, where rocks belong to the 200-million-year-old Redcar Mudstone Formation. It is the fastest eroding stretch of coastline in the whole of Western Europe, with some parts losing an alarming 2 metres of cliff per year. As I watched, sizeable lumps of heavy mudstone slipped from the rain-saturated cliffs, a reminder of the constant forces shaping the planet. The slate rocks in the foreground, once part of the cliffs, now lie strewn on the shore, tumbled smooth by the tide's ebb and flow.

Then there are the other aspects of timing that come together to make this photograph. First, it was taken in May and, unusually, the month is the least important consideration as there is little vegetation to indicate the season. However, it does have a significant effect on the timing and the position of sunrise and sunset. Second, it had to be taken just after sunrise for two important reasons: for the quality of the lighting and because this section of coastline receives side-lighting only in the early morning. Last, the slate platforms forming the boundary between sea and cliffs all but disappear at high tide. To see them fully revealed it needs to be a very low tide. Consulting a tide timetable allowed me to work out when this would coincide with sunrise.

CONCLUSION

The techniques used to help analyse and document the world are by definition flexible: ideas are there to guide creativity, not to rule it. As not all concepts are appropriate for every subject, it is a case of picking and choosing how best to apply them to the scene in front of you. Part of the fun of being an artist is discovering new ways of seeing the world and working them into your practice. An open and inquisitive mind encourages the sensitivity it takes to translate the elusive 'spirit of place' into a photograph.

To reach a receptive state of consciousness requires a degree of quiet, which is why I usually work alone, and also a fair amount of practice. It takes a calm and methodical approach to notice the fluctuations in light levels, the changes in shadow definition and the relative intensities of colour that breathe life and emotional resonance into a photograph. Creativity is not something that can be rushed, so it is better to aim for one masterpiece than it is to produce a dozen average shots that nearly, but not quite, do justice to the scene.

Now, more than ever, it is important to remember that the art of photography is principally about getting the image 'right' in camera. Just because there are ways of 'fixing' problems on the computer, it does not mean that we should come to rely on them. This is not to ignore the advantages of digital technology – I have embraced them in my work – but the greater part of the photographic process happens before the shutter is even pressed. The camera is, after all, a tool for executing ideas and so the thought process behind the image is critical. Poorly developed ideas produce unclear results.

Like all the visual arts, photography is part mastery of technique and part detailed observation. Eventually, when the camera functions like an extension of the body, and less deliberate thought is required to operate it, the mind is free to explore fully and to respond to the environment. Landscape photography is often about thinking not acting, resisting the urge to press the shutter until you are absolutely sure the time is right. As there is a discrepancy between what the eye sees and what the camera is capable of recording, it is vital to visualise how the scene will appear when rendered as a flat image. Not everything that looks good to the eye will provide material for a successful photograph, and the skill to determine this takes time to learn. The clarity that comes with this level of objectivity means knowing the difference between what is likely to make an interesting subject and what will not.

After a period of time making images that are frustratingly far from the idealised view held inside your head, and following a good deal of self-criticism, an individual visual language is

developed. Repeatedly returning to the themes and the compositional arrangements that excite you builds a library of motifs and stylistic flourishes that are unique to you. Needless to say, many ideas need following to a conclusion before you have a broad enough selection of images to begin judging your strengths and weaknesses. This process of intense scrutiny promotes personal insight and the confidence necessary to respond to whatever conditions nature has to offer, ultimately leading to an ability to portray the world instinctively and on your own terms.

Further Reading

Itten, Johannes, *The Art of Color* (John Wiley & Sons, 1974)
The classic treatise on our relationship with and also use of colour.

Gombrich, E.H., *The Story of Art* (16th edition, Phaidon, 1995)
Although photography is mentioned only briefly, I recommend this book because it puts visual art into a historical context. It discusses the development of art from the earliest cave paintings through to modernism, explaining the devices which artist's have used to represent both the real and the imagined worlds.

Gombrich, E.H., *Shadows: The Depiction of Cast Shadows in Western Art* (National Gallery, 1995)
A short introduction to the use of shadows in paintings.

Stewart, Ian, *Nature's Numbers: Discovering Order and Pattern in the Universe* (Phoenix, 1998)
An accessible exploration of the maths that lies behind nature's patterns.

Technical Details

Title page: Boggle Hole: 1/25 & 1/5 sec. f/16, ISO 100. 17mm. Polarising filter used. Two separate RAW files combined together for exposure.

p.6 Swaledale: 0.6 sec, f/22, ISO 100. 91mm. Polarising filter used. RAW file.

p.10 Another Place: 1/2 sec, f/32, ISO 100. 70mm. Polarising filter used. RAW file.

p.16 Kinder Scout: 1/80 sec, f/11, ISO 100. 17mm. Polarising filter used. RAW file.

p.17 Salt Cellar: 1/13 sec, f/16, ISO 200. 19mm. Polarising filter used. Two versions of one RAW file combined together for exposure.

p.18 Trwynhwrddddyn 1/6 sec, f/16, ISO 200. 19mm. Polarising filter used. Two versions of one RAW file combined together for exposure.

p.20 Yarncliffe Wood: 0.6 sec, f/22, ISO 250. 17mm. Polarising filter used. RAW file.

p.21 Callanish I: 1 & 2.5 secs, f/22, ISO 100. 17mm. Polarising filter used. Two separate RAW files combined together for exposure.

p.22 Boggle Hole: 1/25 & 1/5 sec. f/16, ISO 100. 17mm. Polarising filter used. Two separate RAW files combined together for exposure.

pp.24–5 Ob Breakish and Mullach na Carn: From 0.6–1.3 secs, f/22, ISO 100. 26mm. Polarising filter used. Five separate RAW files combined together as a panorama.

p.26 Willow buds: 1/180 sec, f/2.8, ISO 100. 100mm macro. RAW file.

p.27 Elgol: 1/2 sec, f/22, ISO 100. 20mm. Polarising filter used. RAW file.

p.28 Luskentyre: 2 secs, f/22, ISO 100. 17mm. Polarising filter used. RAW file.

pp.30–1 Big Moor: 2 secs, f/8, ISO 200. 17mm. RAW file.

p.32 Black Nab: 1 & 2 secs, f/22, ISO 100. 17mm. Polarising filter used. Two separate RAW files combined together for exposure.

p.34–5 Rhossili beach: From 20–30 secs, f/16, ISO 100. 70mm. Polarising filter used. Three separate RAW files combined together as a panorama.

p.36 Seilebost: 1/5 sec, f/22, ISO 100. 70mm. Polarising filter used. RAW file.

p.38 Micheldever Wood: 0.8 secs, f/16, ISO 200. 73mm. Polarising filter used. RAW file.

p.40 Millstone Edge: 0.6 sec, f/22, ISO 100. 19mm. Polarising filter used. RAW file.

p.42 Upper Booth: 1/8 & 1/3 sec, f/22, ISO 100. 17mm. Two separate RAW files combined together for exposure.

pp.44–5 Loch Ba: 1/3 & 0.6 sec, f/22, ISO 100. 27mm. Polarising filter used. Two separate RAW files combined together as a panorama.

p.47 Freshwater West: 1/2 sec, f/16, ISO 100. 17mm. Polarising filter used. Two versions of one RAW file combined together for exposure.

p.48 Llanberis Pass: 1.3 secs, f/11, ISO 200. 17mm. Polarising filter used. RAW file.

p.49 Balnakeil Bay: 1/80 & 1/30 sec. f/25, ISO 100. 122mm. Two separate RAW files combined together for exposure.

p.53 Longshaw Estate: 1/25 sec, f/22, ISO 200. 20mm. Polarising filter used. RAW file.

p.54 Glen Sligachan and Glamaig: 1/8 sec, f/22, ISO 100. 26mm. Polarising filter used. RAW file.

p.55 Bamburgh Beach: 8 secs, f/16, ISO 100. 17mm. RAW file.

p.58 Duerley Bottom and Dodd Fell: 1/15 sec, f/14, ISO 100. 73mm. Polarising filter used. RAW file.

p.59 Glen Etive, Stob Dubh and Buachaille Etive Mor: 1/6 sec, f/22, ISO 100. 118mm. Polarising filter used. RAW file.

p.60 Ewe Moor: 0.6 sec, f/22, ISO 100. 17mm. Polarising filter used. RAW file.

p.62 Uig Sands: 0.8 sec, f/22, ISO 100. 19mm. Polarising filter used. RAW file.

p.63 Loch Leathen: 1/5 sec, f/22, ISO 100. 26mm. Polarising filter used. RAW file.

pp.64–5 Hound Tor: 1/15 sec, f/16, ISO 100. 17mm. Polarising filter used. Two versions of one RAW file combined together for exposure.

p.66 Porthurno: 1/5 sec, f/18, ISO 100. 40mm. Polarising filter used. RAW file.

p.72 Path from Danebower Quarry: 0.5 & 1 sec, f/22, ISO 100. 17mm. Polarising filter used. Two separate RAW files combined together for exposure.

p.73 Elgol: 0.8 & 2 secs, f/22, ISO 100. 17mm. Polarising filter used. Two separate RAW files combined together for exposure.

p.74 Fields next to Moorside Farm: 1.3 secs, f/22, ISO 100. 154mm. Polarising filter used. RAW file.

p.76 Rannoch Moor, Stob Dearg and bog: 1/4 & 2.5 secs, f/22, ISO 100. 17mm. Two separate RAW files combined together for exposure.

p.77 Mangersta beach: 1/4 sec, f/22, ISO 100. 37mm. Polarising filter used. RAW file.

p.78 Lavernock Point: 1/6 sec, f/16, ISO 100. 40mm. Polarising filter used. RAW file.

p.80 Llyn y Gardair: 0.8 & 1.6 secs, f/16, ISO 100. 17mm. Polarising filter used. Two separate RAW files combined together for exposure.

p.81 Manners Wood: 1/640 sec, f/5, ISO 200. 168mm. RAW file.

p.82 Near Wincle: 1.5 secs, f/22, ISO 100. 17mm. RAW file.

p.84 Stac Pollaidh: 1/6 sec, f/22, ISO 100. 126mm. Polarising filter used. RAW file.

p.85 Faraid Head: 0.6 sec, f/18, ISO 100. 17mm. Polarising filter used. Two versions of one RAW file combined together for exposure.

pp.86–7 Llyn Idwal, Glyderau and Pen yr Ole Wen: 1/5 & 1/4 sec, f/16, ISO 100. 29mm. Polarising filter used. Two separate RAW files combined together as a panorama.

p.89 Portwrinkle: 1/30 sec, f/22, ISO 100. 24mm. RAW file.

p.90 Woods Moss: 1/4 sec, f/22, ISO 100. 17mm. Polarising filter used. RAW file.

p.91 Thwaite Scars: 1.3 secs, f/16, ISO 100. 36mm. RAW file.

p.94 Taigh Bhuirgh: 0.6 sec, f/22, ISO 100. 17mm. Polarising filter used. RAW file.

p.95 Ramsley Moor: 1/40 sec, f/22, ISO 100. 180mm. RAW file.

p.96 Loch Coralach: 30 secs, f/11, ISO 100. 28mm. Polarising filter used. Two separate RAW files combined together as a panorama.

p.98 Perranporth arch: 1/5 & 1.6 secs, f/22, ISO 100. 17mm. Polarising filter used. Two separate RAW files combined together for exposure.

p.99 The Fairy Glen: 1/25 sec, f/5, ISO 100. 140mm. Polarising filter used. RAW file.

p.100 Castleton fields: 0.6 sec, f/22, ISO 100. 159mm. Polarising filter used. RAW file.

p.102 Glen Affric: 1/60 & 1/6 sec, f/16, ISO 100. 22mm. Two separate RAW files combined together for exposure.

p.103 Roseberry Common: 1/15 sec, f/16, ISO 200. 159mm. Polarising filter used. RAW file.

p.104 Snowdrop: 1/100 sec, f/2.8, ISO 250. 100mm macro. RAW file.

p.106–7 Godrevy Point: 1/20 sec, f/22, ISO 100. 17mm. Polarising filter used. RAW file.

p.108 Callow Bank: 1/13 sec, f/22, ISO 100. 30mm. Polarising filter used. RAW file.

p.109 Torridon Forest: 1/8 sec, f/18, ISO 200. 23mm. Polarising filter used. RAW file.

p.111 Dunstanburgh Castle: 4 secs, f/22, ISO 100. 70mm. Polarising filter used. RAW file.

p.112–13 Kinder Scout and Bleaklow: From 1/80–1/20 sec, f/16, ISO 200. 113mm. Three separate RAW files combined together as a panorama.

p.114 Chee Dale: 1/160 sec, f/4, ISO 100. 200mm. RAW file.

p.117 White Scars: 0.6 sec, f/22, ISO 100. 17mm. Polarising filter used. RAW file.

p.118 Corfe Castle: From 1/400–1/50 sec, f/22, ISO 100. 70mm. Two separate RAW files combined together for exposure.

p.119 Whitby: 1/30 sec, f/16, ISO 100. 33mm. Polarising filter used. RAW file.

p.120 Cape Wrath: 60 secs, f/20, ISO 200. 22mm. Polarising filter used. RAW file.

p.125 Luskentyre: 1/8 sec, f/22, ISO 100. 22mm. Polarising filter used. RAW file.

p.126 Snowdon Range and Glyder Fawr: 10 secs, f/11, ISO 200. 22mm. RAW file.

p.127 Ullswater: 90 secs, f/22, ISO 100. 26mm. Polarising filter used. Two versions of one RAW file combined together for exposure.

p.129 Spring Wood: 1/250 sec, f/6.3, ISO 100. 200mm. RAW file.

p.130 Bedruthan Steps: From 1/8–1/2 sec, f/20, ISO 200. 20mm. Two separate RAW files combined together for exposure.

p.131 Wasdale: 1/5 sec, f/16, ISO 100. 20mm. RAW file.

p132–3 Glyder Fach: 1/6 sec, f/22, ISO 100. 109mm. Four separate RAW files combined together as a panorama.

p.135 Glen Etive, Lochan Urr and Stob Dubh: 1/10 & 1/8 sec, f/22, ISO 100. 17mm. Two separate RAW files combined together for exposure.

pp.136–7 Afon Nant Peris: 1/5 & 0.6 sec, f/16, ISO 200. 17mm. Two separate RAW files combined together for exposure.

p.138 Uisgnebhal Mor and Teileasbhal: 0.6 sec, f/22, ISO 100. 17mm. Polarising filter used. RAW file.

p.140–1: Saltwick Bay: 1/2 sec, f/16, ISO 100. 17mm. Polarising filter used. Two separate RAW files combined together as a panorama.